STORM CHASER
A Visual Tour of Severe Weather

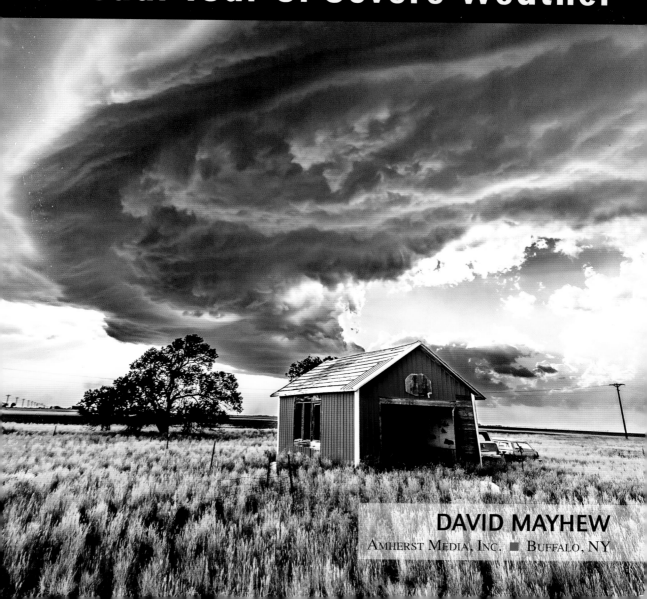

DAVID MAYHEW

AMHERST MEDIA, INC. ■ BUFFALO, NY

Published by:
Amherst Media, Inc.
PO BOX 538
Buffalo, NY 14213
www.AmherstMedia.com

Publisher: Craig Alesse
Senior Editor/Production Manager: Michelle Perkins
Editors: Barbara A. Lynch-Johnt, Beth Alesse
Acquisitions Editor: Harvey Goldstein
Associate Publisher: Kate Neaverth
Editorial Assistance from: Carey A. Miller, Roy Bakos, Jen Sexton-Riley, Rebecca Rudell
Business Manager: Adam Richards

ISBN-13: 978-1-68203-296-1
Library of Congress Control Number: 2017939278
Printed in the United States of America
10 9 8 7 6 5 4 3 2 1

AUTHOR A BOOK WITH AMHERST MEDIA!

Are you an accomplished photographer with devoted fans? Consider authoring a book with us and share your quality images and wisdom with your fans. It's a great way to build your business and brand through a high-quality, full-color printed book sold worldwide. Our experienced team makes it easy and rewarding for each book sold—no cost to you. E-mail **submissions@amherstmedia.com** today!

www.facebook.com/AmherstMediaInc
www.youtube.com/AmherstMedia
www.twitter.com/AmherstMedia

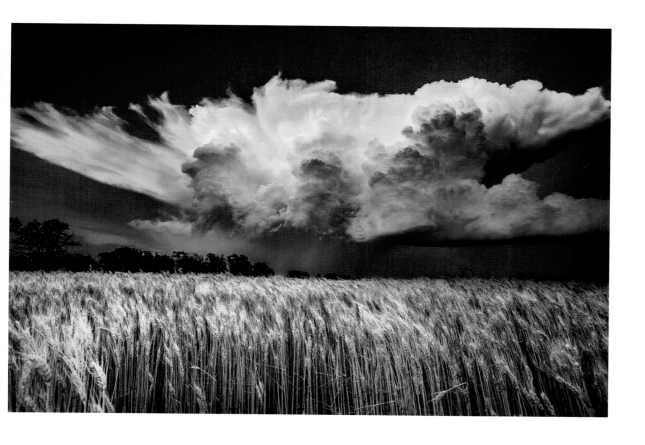

ABOUT THE AUTHOR

Born in the UK, David Mayhew initially studied for a bachelor's degree in engineering design. His sense of adventure took him on a nineteen-month global exploration, but it wasn't until David moved to Italy and began working in the automotive industry that digital photography caught his eye. In 2003, David decided to bail out of the 9-to-5 environment to delve head first into photography. He began to study photography at the College of DuPage near Chicago, where he also joined forces with the school's meteorology program and gained sufficient knowledge to forecast severe weather for storm chasing.

David has seen some unique and beautiful sights, including the largest-ever-recorded tornado (2.6 miles wide in El Reno, Oklahoma, May 31st, 2013) and has put himself in precarious situations! Now based in Colorado by the foothills of the Rocky Mountains, David is ideally located for heading east to tornado alley or west to explore the mountains for the landscapes of the southwest.

David shows his ever-expanding portfolio of work in galleries, museums, and art festivals across the country. He received Best in Show, People's Choice, and Gold Imaging awards at the 2016 Las Vegas SGIA expo.

David's works have appeared in various publications, such as *Scientific American* and *Sky & Telescope;* an article on his work appeared in *PDN* magazine in July 2016.

David's work has been made grounds in photo contests, such as the National Geographic Traveler and Santa Fe contests. He is an active member in the storm chase community, showing work at the National Weather Center and Chaser Con. He is also a judge in the annual Weather Channel photo competition.

You can connect with David at:

www.davidmayhewphotography.com
www.facebook.com/davidmayhewphotography
www.instagram.com/davidmayhewstormpix/.

Weather has always fascinated me. As a kid, I would watch lightning storms no matter the time of night. When I moved to the United States, I was eager to experience the raw beauty of the untamed storms of tornado alley. So I hooked up with a college's annual storm chase trip and, as an added bonus, learned to forecast. This eventually allowed me to venture out under my own steam.

Capturing the moods of the sky—those one-off fleeting moments that will never be repeated—became my challenge. Each scenario has a distinctive personality. The photos selected for this book will take you on a journey into the emotions of the sky; some you may have encountered yourself, others are rarer gems I have encountered on my continued travels of discovery.

We perceive the sky as being inspiring and a place of freedom. We consider the sky to be the heavens above. We envy the bird that floats on its currents. We lose ourselves in the majesty and vastness of the stars at night. Even Olympus, the kingdom of the ancient Greek Gods, was built on top of the clouds!

Remember to keep an eye on the sky!

SEVERE WEATHER

BEAM ME UP *(top)*

A great UFO-shaped structure from a supercell storm. 1.5-inch hail was produced and refracted light to the turquoise color. Saint Paul, Nebraska. May 4th, 2012.

ORANGE TWIST *(bottom)*

Here, a fiery sunset lights up the underside of the amazing structure of a supercell storm that produced a tornado near Calhan, Colorado, on June 7th, 2012.

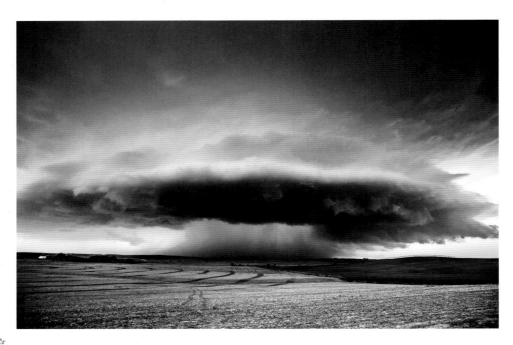

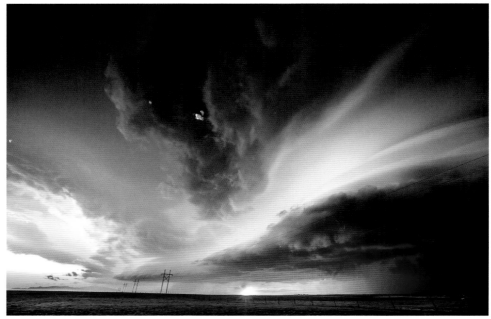

THE YELLOW BRICK ROAD

(top)

A tornado-producing super-cell storm shows its splendid formations. The storm was reorganizing at this point the image was made between the time it produced two tornadoes. The wall cloud on the right was dying out and a new wall cloud was forming above the road. The blue color is believed to be the result of heavy hail. A distant lightning bolt can be seen on the horizon.

If I had a time machine, I'd take my current camera and chasing knowledge for a do-over of this day! Badlands National Park, South Dakota. June 6th, 2007.

HIGH-BASED SPIN UP

(bottom)

Chasing the high plains is one of my favorite ways to see storms. Storms tend to have great structure in the higher-elevation states of Colorado and Wyoming. Western Kansas and Western Nebraska are prime areas, too. However, these storms tend to be a tease, as they seem to struggle to produce tornadoes, particularly strong ones. Here, I had to be content with a little vortex near Pine Bluffs, Wyoming. July 10th, 2013.

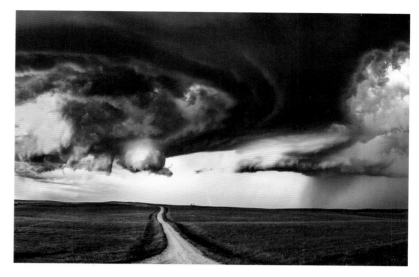

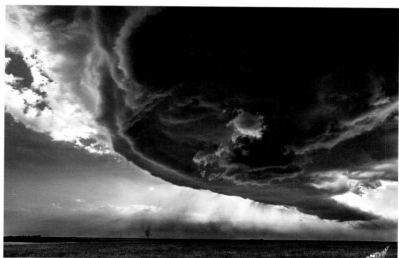

FIST OF FURY *(pages 8–9)*

My favorite tornado ropes out from my best chase day ever. See the full tornado life cycle on pages 28–33. Norton, Kansas. May 20th, 2011.

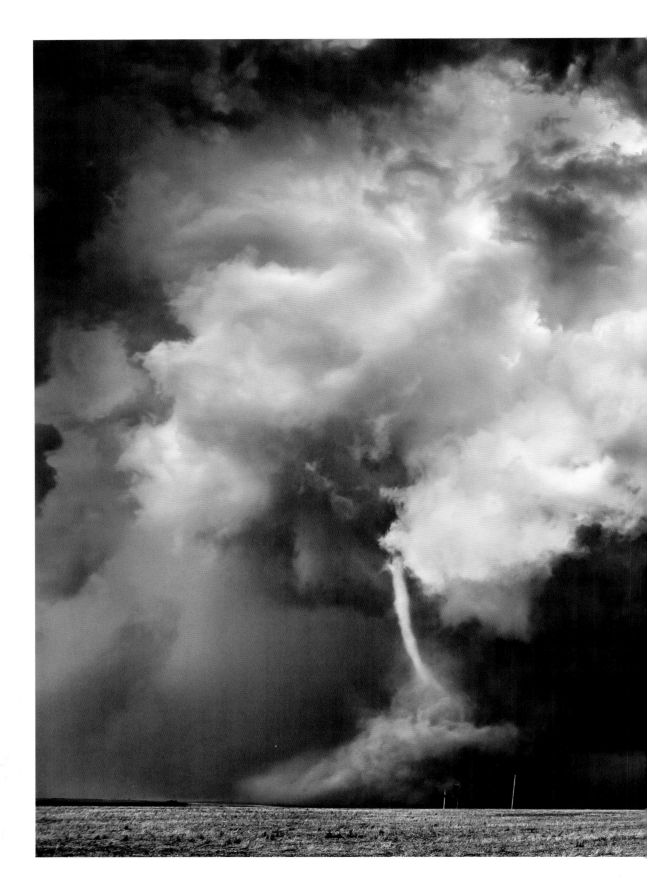

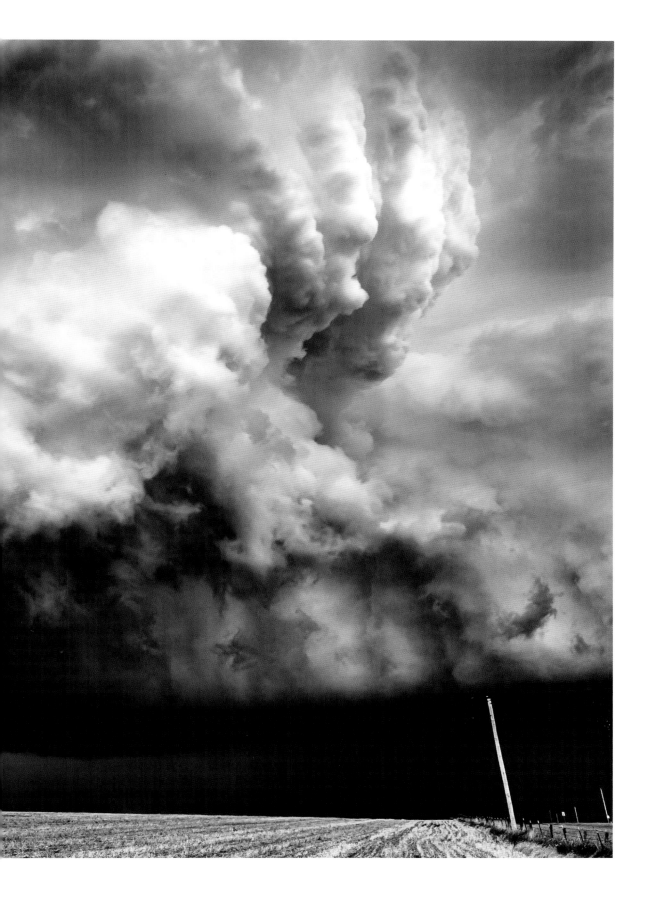

NEEDLE ON THE RECORD *(top)*

Image 1 of 4. Touchdown! One of my earliest tornadoes, photographed on April 29th, 2009, near Floydada in the Texas Panhandle. Improvements in editing software have led to much better handling of shadows and highlights, so I only managed to bring out the detail of this piece in 2016. 6:13:36PM.

VORTEX *(bottom)*

Image 2 of 4. The tornado maintains an odd crayon shape as it crosses the road. 6:14:41PM.

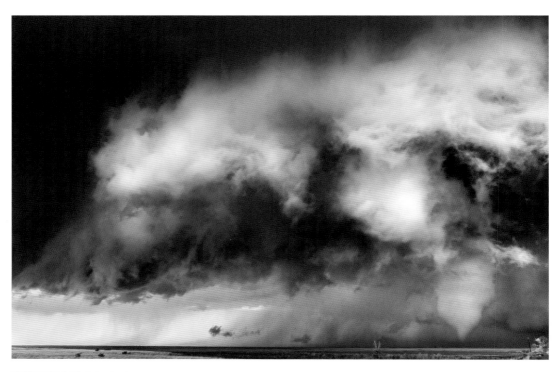

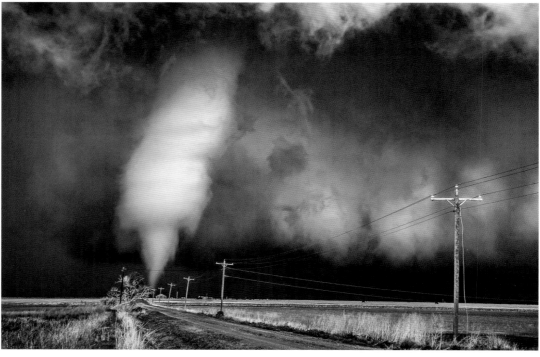

CLOSE ENCOUNTER *(top)*

Image 3 of 4. A wider shot shows just how long the tornado funnel is as it passes behind an abandoned house. 6:14:44PM.

CAROUSEL *(bottom)*

Image 4 of 4. As the storm spins around like a carousel, a second tornado forms in the distance, seen to the right of the main tornado. 6:15:23PM.

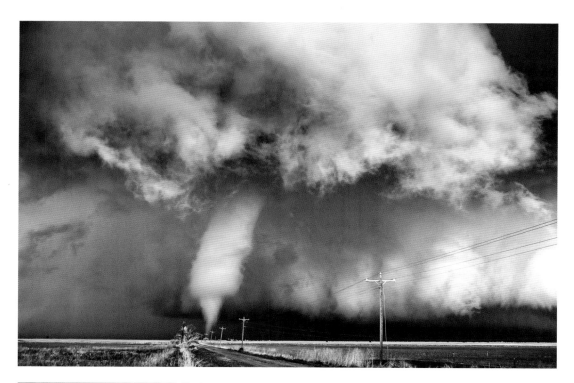

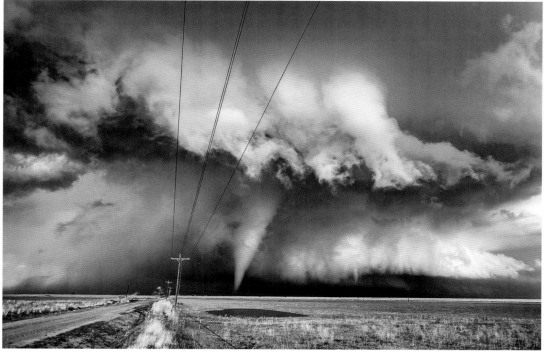

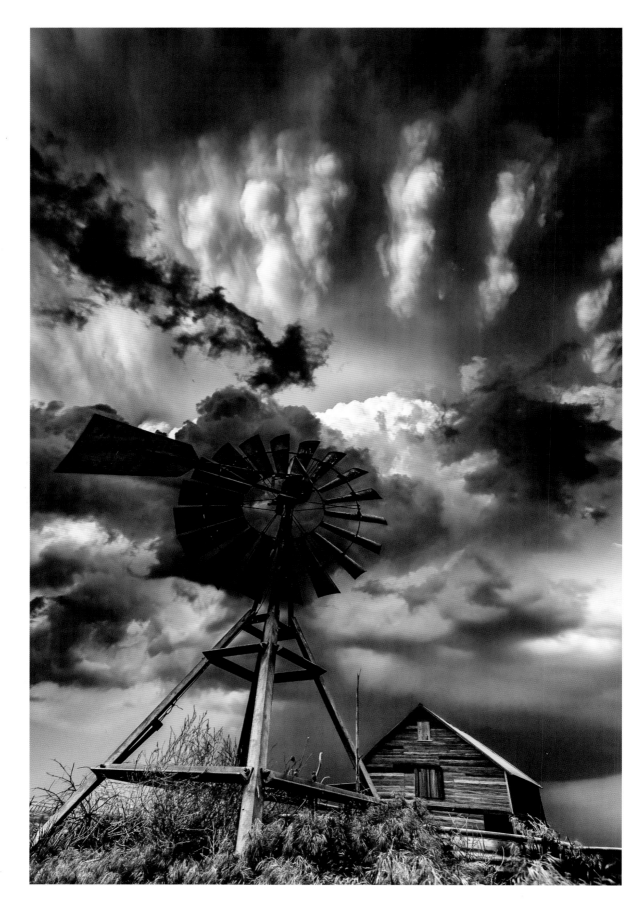

CLOUD OF WITNESSES *(previous page)*

Storm clouds on the high anvil loom over an old barn and windmill, taking on the shape of a celestial army. Windmills like these are slowly disappearing from the plains. It's a real shame, as they have such history and are a reminder of farming days of the past.

This image was made on May 20, 2014, as the sun had begun to set. 8:50PM.

FARM ANVIL *(top)*

A wider shot shows the structure of the anvil as it slowly moves away. After finding a treasure like this one near Flagler, Colorado, it was a no-brainer to stay there for four hours to watch the changing light and the variety of different photos it offered, even though it meant sacrificing the chase and possibly missing a tornado. Fortunately, it did not produce one, and the resulting shots were worth the gamble. 9:07PM.

EARTH, WIND & FIRE

(bottom)

As modern cameras allow for shooting at higher ISOs with less noise, photographing at night allows for a whole new range of capture possibilities. Here, I used a flashlight to "paint" the barn and windmill with light while capturing the lightning storm and the stars in the sky. I really lucked out and was also able to capture a shooting star! If only I'd thought to throw a coin in the well and make a wish!

With changing light, I managed to get five or more completely different top-selling shots. Patience is a virtue!

This was a 30-second exposure. My dad thoroughly enjoyed his first storm chase day with me. 10:19PM.

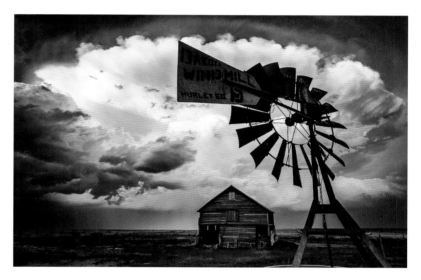

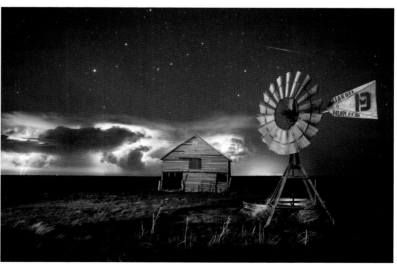

FIRST CONTACT *(top)*

Image 1 of 6. A rapidly rotating wall cloud took quite some time before its final touchdown. This is probably the only time I've seen a column of concentrated dust rise up in the air as shown. Aurora, Nebraska, June 17th, 2009. 8:58PM.

HOOK ECHO *(bottom)*

Image 2 of 6. Even though the condensation funnel has not reached the ground, the rotating debris cloud is evidence that the tornado has touched down.

The winds are the tornado, not the funnel. This is important to remember when chasing; if you end up in the circulation, you are technically in the tornado. Strong tornadoes can often have suction vortices within the circulation that have extremely fast rotation and are therefore quite dangerous. 9:01PM.

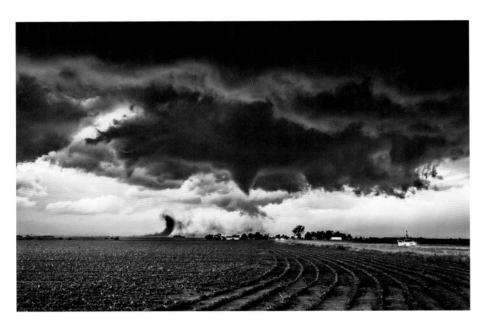

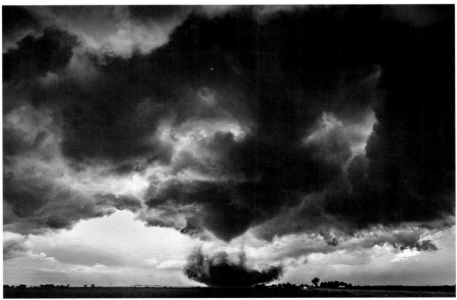

ELEPHANT TRUNK *(top)*

Image 3 of 6. The shape of this tornado is called an "elephant trunk" for obvious reasons. The tornado followed highway 34 pretty much due east. Although it looks powerful due to its size and the debris it is kicking up, the tornado was only rated an EF2 on a scale that reaches a maximum of 5. Size is not always an indication of strength. The widest-ever tornado, at 2.6 miles wide (see page 39), was only rated an EF3. I have seen very narrow tornadoes with intense rotation like a drill bit that are more intense. 9:08PM.

AURORA TORNADO DECLINE *(bottom)*

Image 4 of 6. The tornado started to decline as the funnel lifted, but rotation on the ground persisted a while longer. 9:12PM.

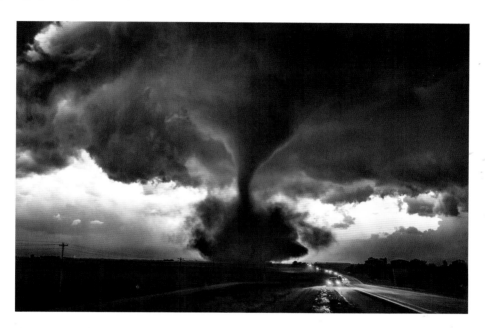

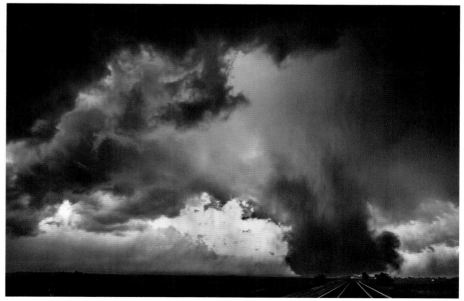

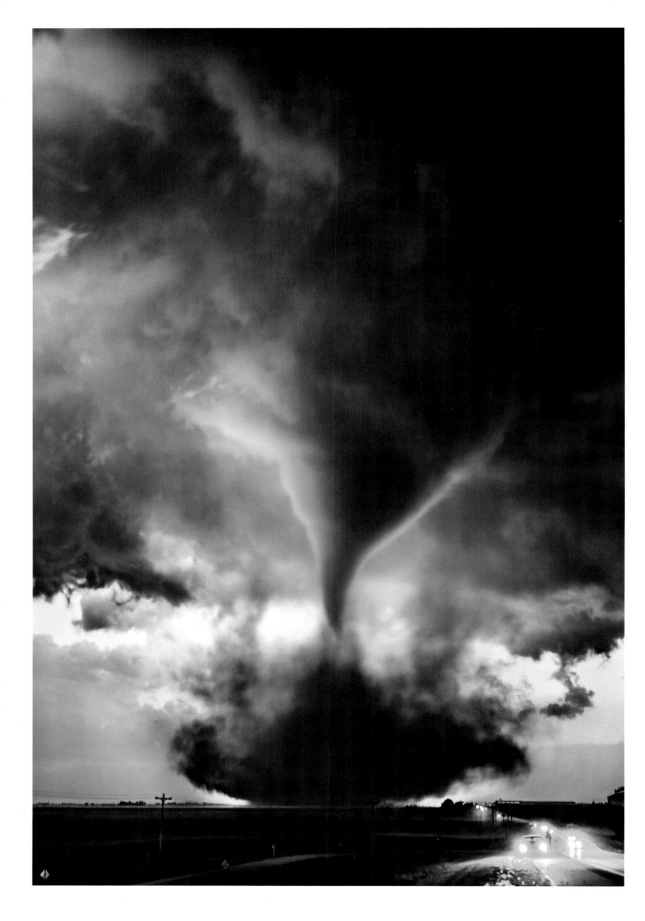

AURORA TWISTER (previous page)

Image 5 of 6. A closer zoom shows more detail, including a red barn about to be destroyed by the tornado, just on the right from the top of the telephone pole near the center of the image. The twister also took out a pet food plant and a storage unit located on the right of the frame. 9:08PM.

BILLOWING CLOUDS (below)

Image 6 of 6. The tornado had lifted by this point, but you can still see the rotation in the clouds in this 15-second exposure. The storm was over the I-80 corridor near York, Nebraska. I would have used my wide-angle lens, but it popped off my belt in its case during the excitement of the chase! 9:50PM.

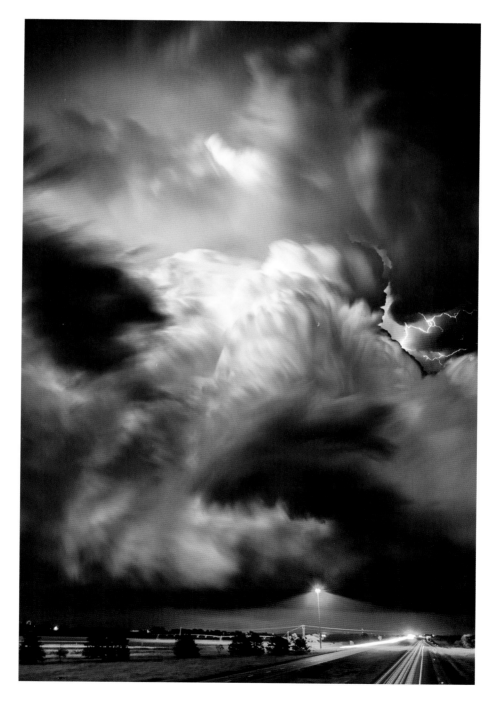

BEYOND QUESTION (below)

Image 1 of 4. I am frequently amazed by how quickly a storm can morph from one form to another in such a short time. It can be a truly mesmerizing experience.

Here, a tornado makes a touchdown for literally a second or two and then takes the shape of a question mark, as if to ask, "What am I going to do next?"

This image was captured in Rush Center, Kansas. May 25th, 2008. 4:05PM.

WORM HOLE (following page)

Image 2 of 4. The tornado lifts and morphs into a multi-limbed "worm hole," as if it were a portal to another dimension. 4:08PM.

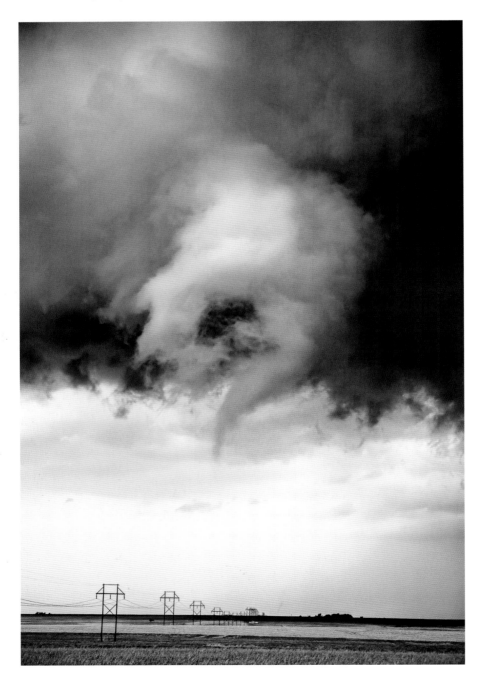

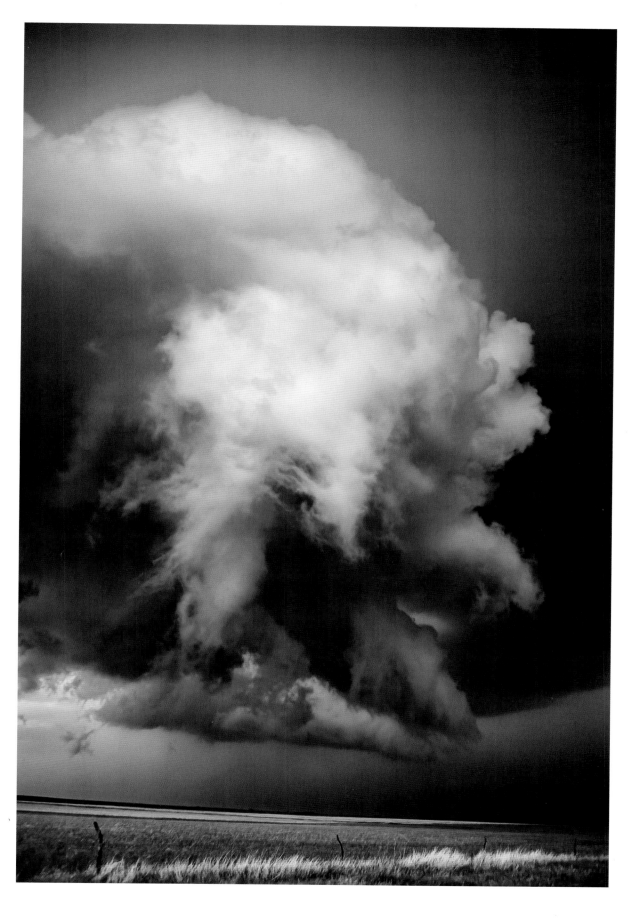

CROISSANT (top)

Image 3 of 4. This is actually the photo from between the Beyond Question tornado and the Worm Hole image (both shown on page 18) with 90 seconds between each shot. 4:06PM.

FACING THE ELEMENTS (bottom)

Image 4 of 4. At 4:10PM it crossed the road with a completely different formation, but this prominent lowering wall cloud failed to produce another tornado.

Storm chasers watch it pass by as a fire engine gets in position to respond to any emergency that may arise.

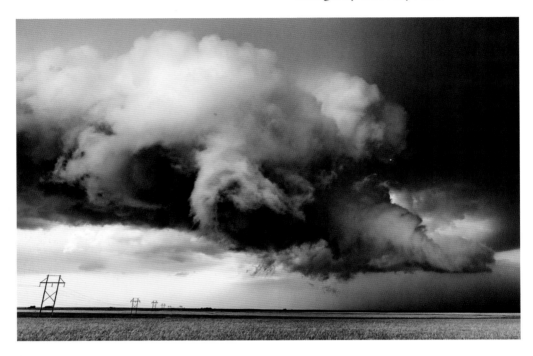

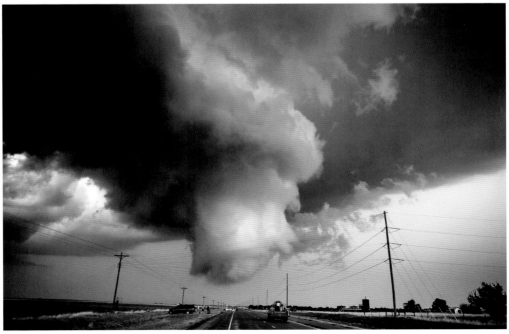

COLLYER TORNADO (top)

It was an active few weeks for Western Kansas. This tornado appeared three days before the Beyond Question tornado and only about 70 miles away. It's a chaser's dream to have a few days of storms close to each other. An average chase day for me is 500–800 miles, with my record being 1100 miles.

Here is a great example of a clear slot, an area of descending air called the "rear flank downdraft" that is key in the formation of tornadoes.

IN FLOW (bottom)

As the storm kicks up dust it obscures the tornado from view. As the clear slot continues to wrap around the mesocylcone, it opens up a window to the core of the storm. The blue-green color is believed to be hail refracting light, producing colors similar to that of ice in a glacier.

A dust-nado spins up on the outflow from the storm (far left) and the headlights of a storm chaser emerge from the storm at the end of the road.

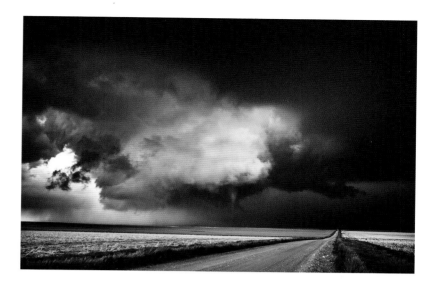

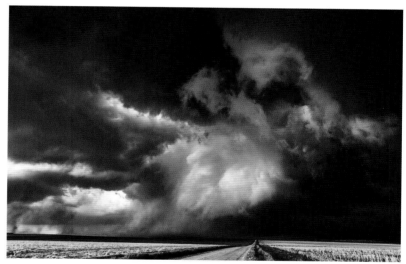

THE STRENGTH WITHIN (pages 22–23)

The awe-inspiring power of a supercell storm as the updraft is hit by the last light of the day. Pileus clouds atop the climbing cumulus towers indicate the sheer power of the explosive storm, which produced hail over 1 inch in size. Ponca City, Oklahoma. June 9th, 2009.

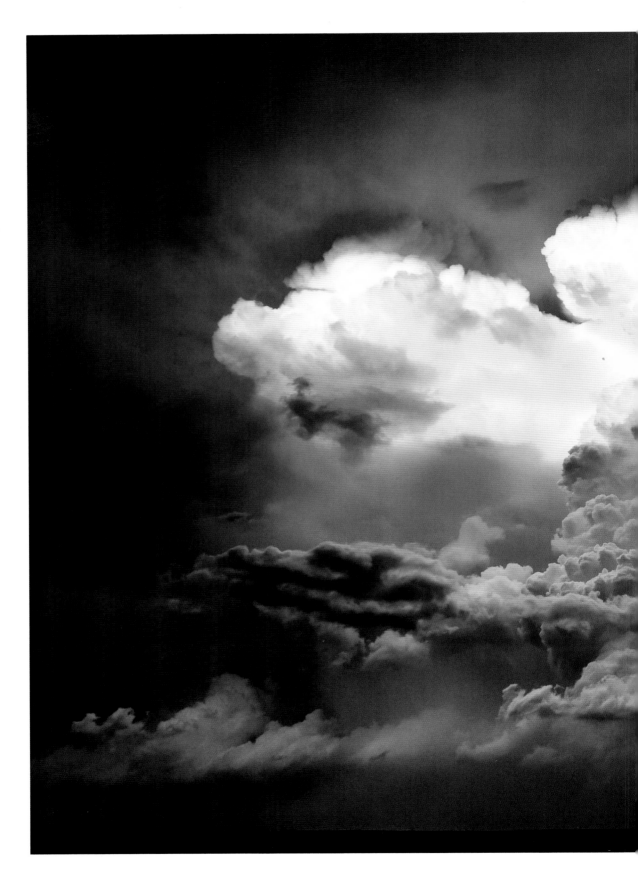

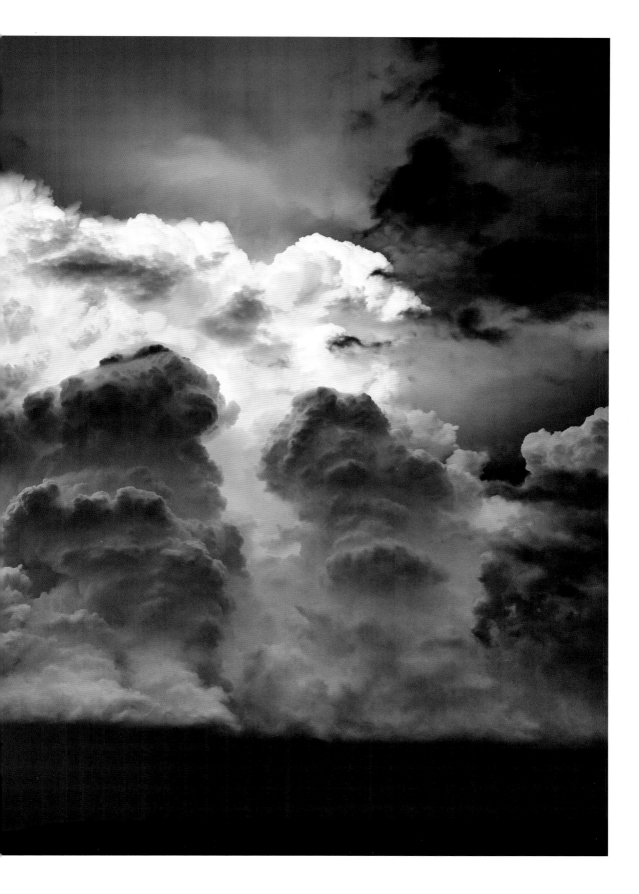

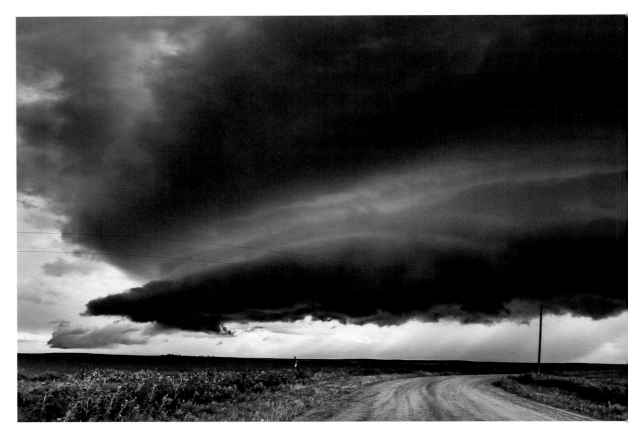

MOMENTUM *(above)*

A great shelf cloud hovers over fields as it surges forward during a rare late-summer chase. Sunflowers, seen on the roadside, tend to grow to full size in mid August.

This image was captured near Akron, Colorado, on August 7th, 2015.

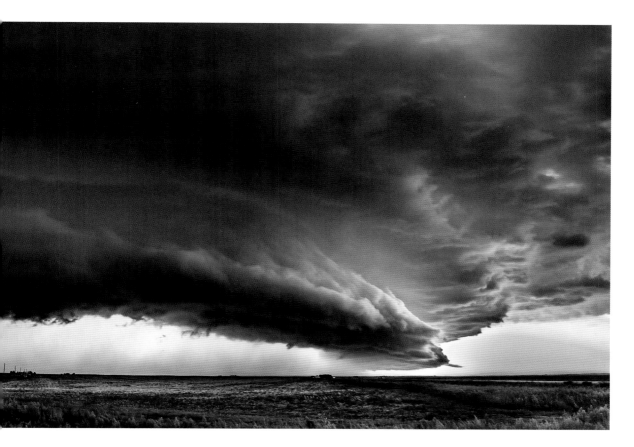

A great shelf cloud hovers over fields as it surges forward during a rare late-summer chase.

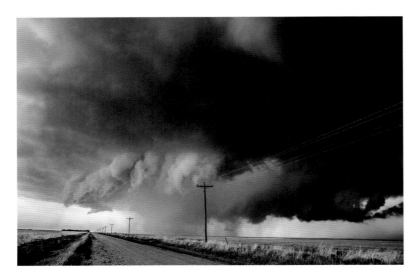

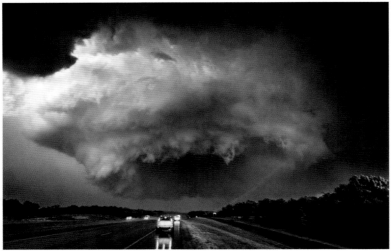

KANSAS STORM (top)

Most people think that storms are surrounded by strong winds. Often they are, especially if you are in the inflow winds being drawn into the storm, or outflow winds in a mature or dying storm that is said to be gusting out. But at times there can be an ominous stillness, as was the case here.
I recall watching this storm and enjoying the pleasant songs of birds chirping away merrily. Near Alanthus, Kansas. May 22nd, 2008.

PORTAL (bottom)

I set up an art fair in Oklahoma City in the morning, chased this storm in the afternoon, and opened up the show at 6:30AM the next day!

An ominous and wide mesocyclone produced multi-vortex tornadoes beneath it, leaving a swath of damage and one fatality. One thing that is not often thought of is the smells associated with tornadoes. Here, a wide swath of trees were torn down, creating a smell of freshly mowed grass. Tushka, Oklahoma. April 14th, 2011.

CROP CIRCLES *(top)*

Image 1 of 2. Early initiation (2:26PM) created a crisp supercell storm that produced a brief tornado. Being late in the storm chase season, crops were growing, allowing for great photo opportunities. Oketo, Kansas. June 17th, 2009.

FIELD OF DREAMS *(bottom)*

Image 2 of 2. The crispness of the storm sharpened up even more, showing a nice stacked-plate or mothership formation.

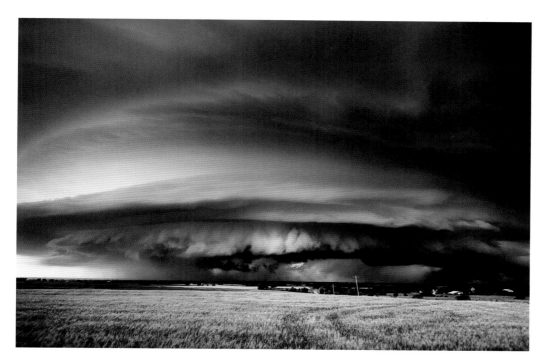

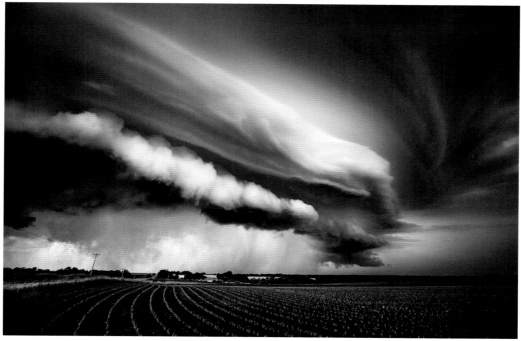

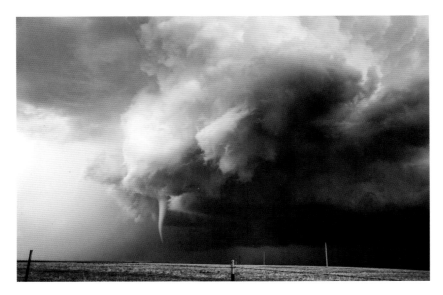

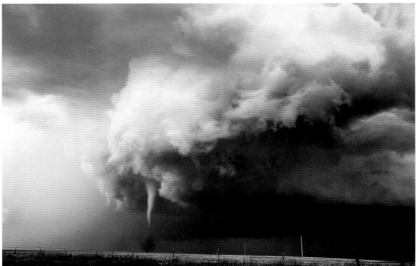

NORTON TORNADO #2 *(top)*

Image 1 of 11. What a chase day! I was eying the frontal boundary to my south when a tornado warning was issued. I dashed out from my lunch at *Pizza Hut*, and as I pulled up to my target intercept location, I looked at the radar to gauge where it should be, I glanced up—and it was right there! The new funnel was just forming in front of me. Near Norton, Kansas. June 20th, 2011.

2:29:22PM

NORTON TORNADO #3 *(bottom)*

Image 2 of 11. I pulled off on the side of the main road with engine running and my car turned around, ready to escape. I watched in awe as the funnel started to kick up dirt.

2:29:48PM

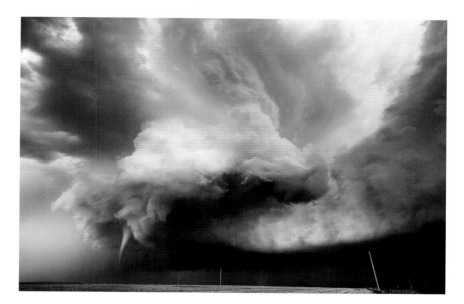

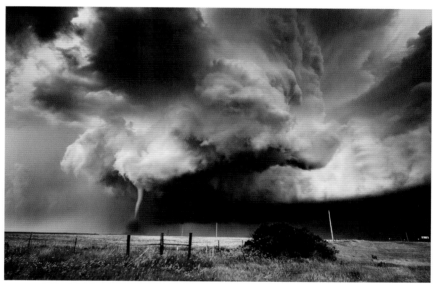

SKY SONG (top)

Image 3 of 11. A wider-angle shot (21mm) shows the incredible structure of the storm with a beautiful soft palette of color. If you take a look, you can see a second tornado. Halfway between the two nearest telephone poles and up you will see the small funnel. In line with the funnel on the ground is a small debris cloud.

2:30:20PM.

TWIST AND SHOUT (bottom)

Image 4 of 11. The longer the tornado is on the ground, the more debris it kicks up. This was a rare cold core tornado and had a white paper written on it by meteorologist Jon Davies. Google "Jon Davies Norton Tornado June" to read it.

2:31:02PM.

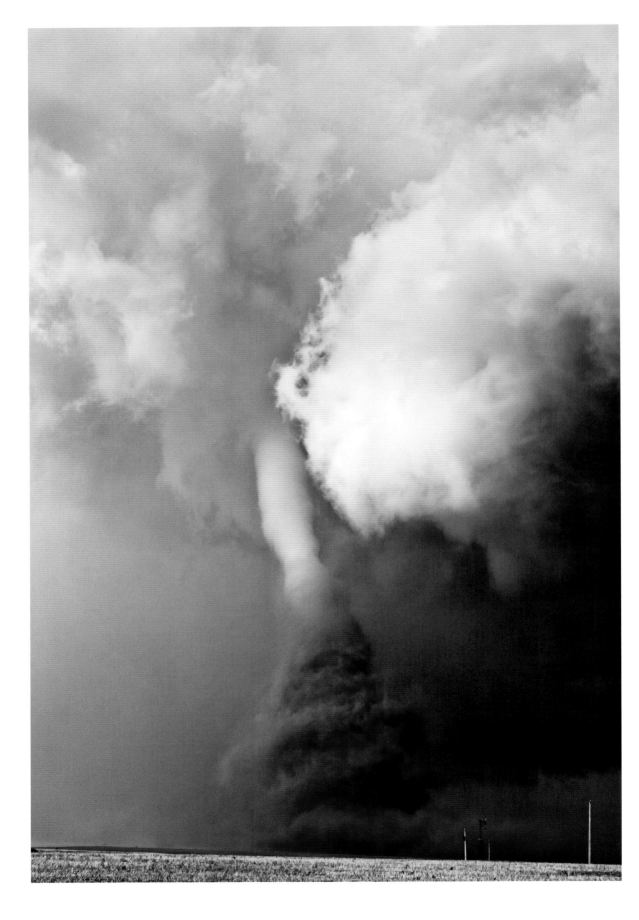

FOREBODING WINDS #1 *(previous page)*

Image 5 of 11. Zoomed in at 70mm (yup, I was less than a mile from it), you can really see the detail in the rotating dust cloud. This stovepipe formation appeared when the tornado reached its strongest, EF3.

It took me one minute to run to my car to change lenses!

2:32:08PM.

DUST DANCE *(top)*

Image 6 of 11. It's a very subtle change, but you can see that the tornado is starting to narrow. Until I noticed the change, I was getting ready to move out. You can still see the second tornado on the right, halfway between the closest telephone pole and edge of the frame.

2:32:22PM.

FOREBODING WINDS #2 *(bottom)*

Image 7 of 11. The dust starts to plume downward.

2:32:24pm.

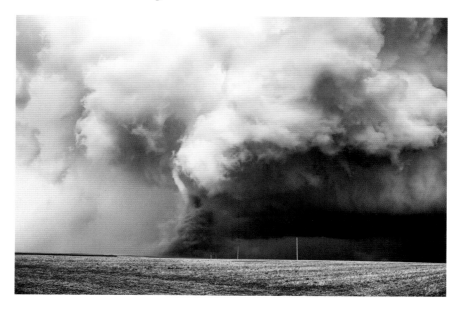

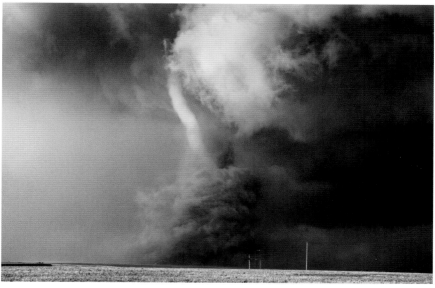

FIST OF FURY (top)

Image 8 of 11. Don't be distracted by the tornado roping out and dropping the dust; check out the power in the storm—particularly the knuckles of the billowing climbing cumulus tower in the top right. You know this storm is still going strong, with more tricks up its sleeve!

2:32:37PM.

NORTON TORNADO #17 (bottom)

Image 9 of 11. A totally collapsing tornado with the debris dust dropping right out.

2:32:46PM.

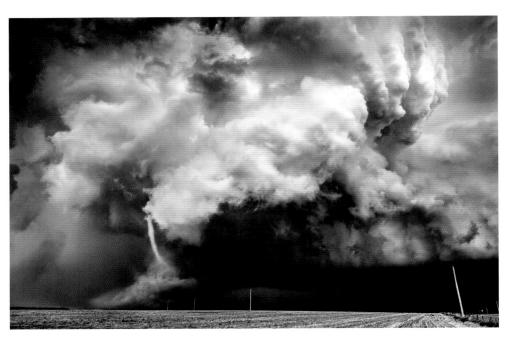

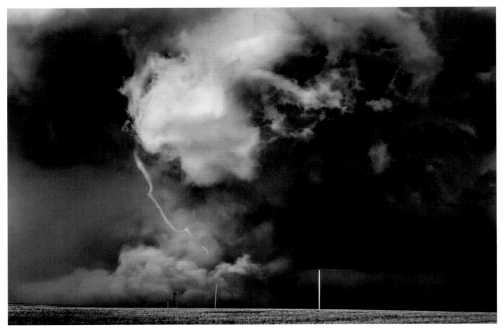

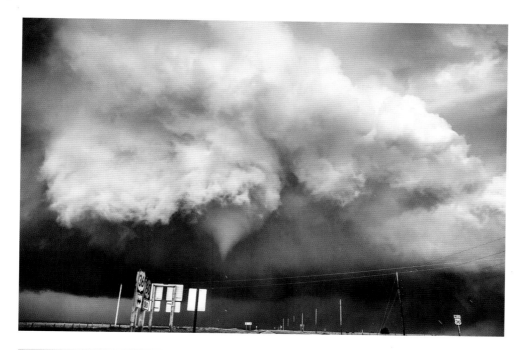

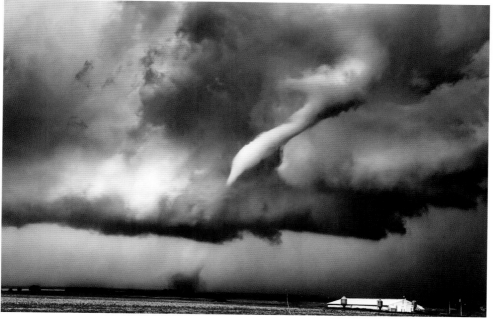

THE STING *(top)*

Image 10 of 11. A third tornado drops as the storm crosses the road near Norton, Kansas. You can see the heavy hail that prompted me to move on.

 2:35:02PM.

QUICK SPIN *(bottom)*

Image 11 of 11. Another of the seven tornadoes I saw on June 20th, 2011. This one lasted only about 45 seconds.

 3:31PM.

ON THE BRINK OF DESPAIR *(top)*
Prior to a brief tornado touchdown, the ominous clouds loom over a barn near Washington, Kansas. April 29th, 2010.

HIGH PLAINS HIGH BASE *(bottom)*
A great structure from the high plains of Wyoming. July 10th, 2013.

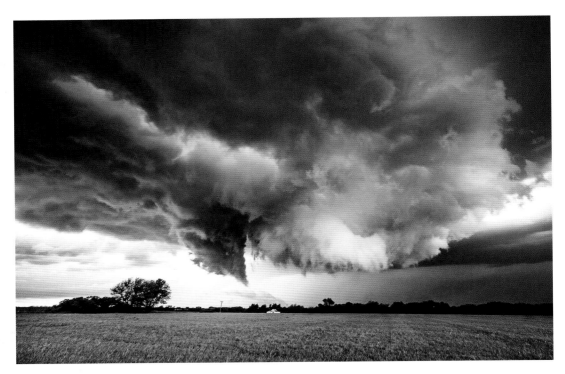

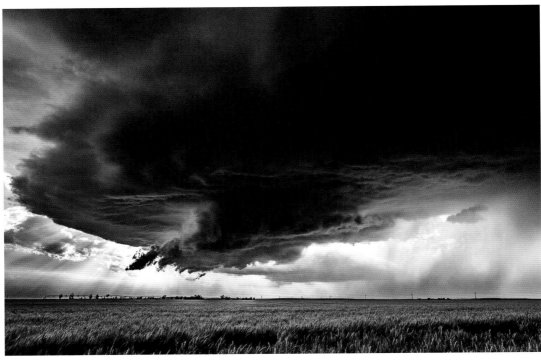

ANTICIPATION *(top)*

The high plains can be such a tease! There are many great-looking storms that appear promising but never complete a touchdown. This slowly rotating funnel lowered and lowered for a few minutes, making it look like a touchdown was imminent. Alas, this image shows as far as it got. Fifteen minutes later, the storm dissipated and the sun came back out. South of Stoneham, Colorado. June 17th, 2013.

BEAVER CROSSING TORNADO *(bottom)*

The Beaver Crossing tornado came from a high precipitation (HP) supercell and so was rain wrapped and hard to see. It was 1.5 miles wide and an EF3.

While scooting south to move away from the tornado, I was hit by 100mph rear flank downdraft (RFD) winds that blew out my three side windows. Telephone poles behind me bent and snapped off. You may have seen the video of an irrigation system such as the one pictured (it might have been this one!) blow into the car of another storm chaser. Beaver Crossing, Nebraska. May 11th, 2014.

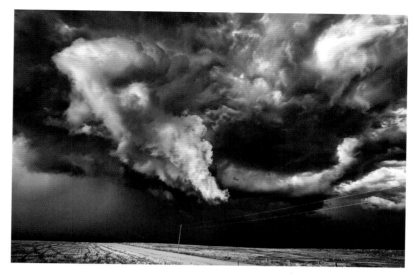

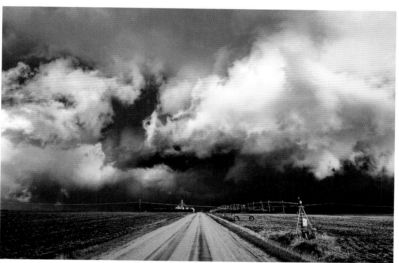

OFF THE RAILS 2016 *(pages 36–37)*

While chasing in Southeast Colorado, a storm formed over me, behind my initial targeted storm. Kit Carson, Colorado. June 18th, 2011.

The high plains can be such a tease! There are many great-looking storms that appear promising but never complete a touchdown.

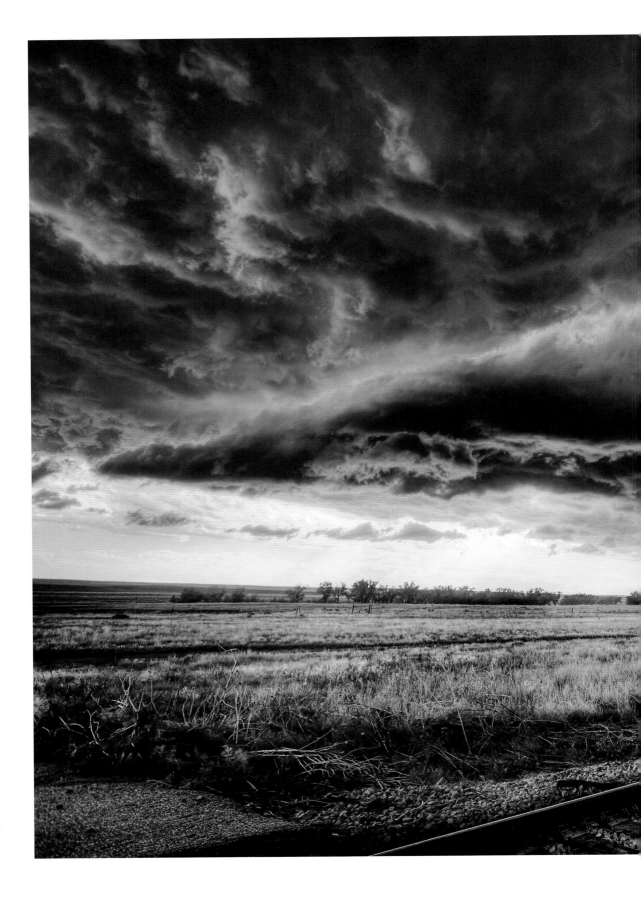

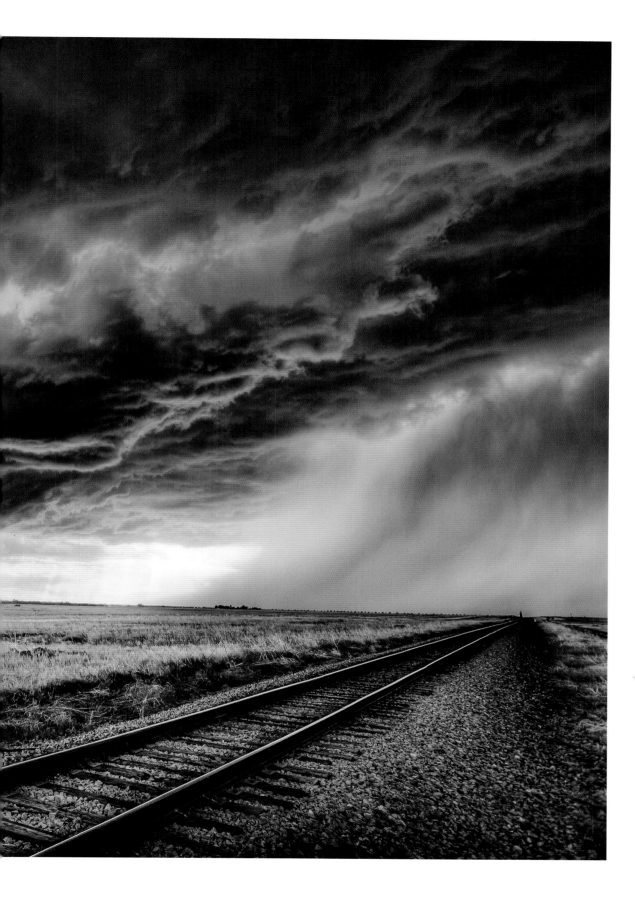

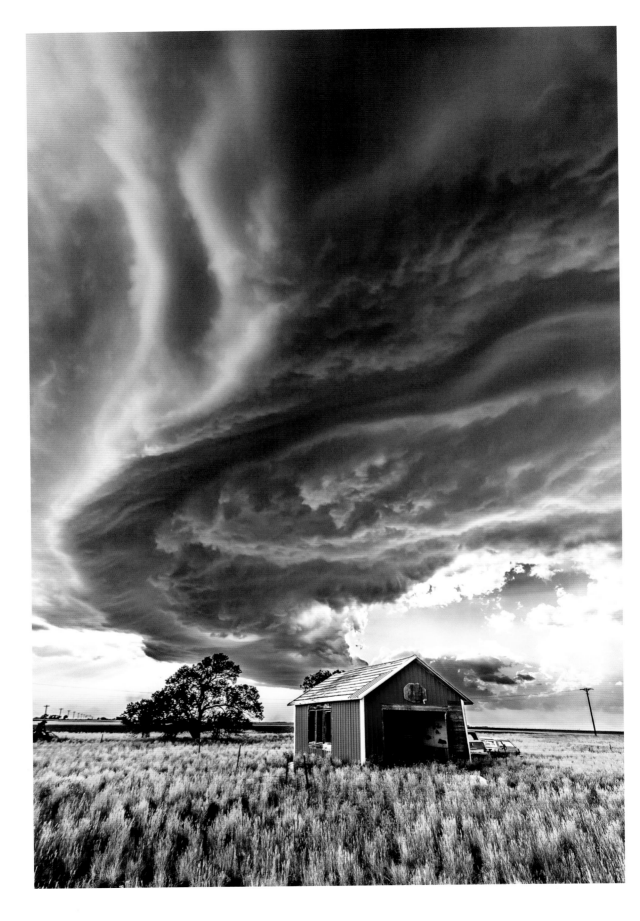

WINDS OF CHANGE *(previous page)*

Detailed cloud formations wrap around the back end of a storm that exhibited some rotation and produced a couple of dust-nadoes. Northern Colorado, due south of Pine Bluffs, Wyoming. July 10th, 2013.

EL RENO #36 *(top)*

Image 1 of 2. The renowned El Reno tornado is the widest in recorded history, reaching a whopping 2.6 miles wide, beating the previous record of 2.5 miles held by the Hallam, Nebraska, tornado which I was also fortunate enough to witness. Both storms were HP super-cells and wrapped in rain, making them difficult to distinguish.

This image was captured in the early stages of the initial touchdown. It was taken by the El Reno regional airport on May 31st, 2011.

EL RENO #44 *(bottom)*

Image 2 of 2. Here the storm has reached its maximum width of 2.6 miles, but due to the rain it is hard to make out. It was as if the cloud was on the ground. I had to really boost the contrast to show detail.

Fellow chasers were caught in the outer edge of the circulation within which were strong suction vortices. It was one of these that is believed to have taken the lives of friends Carl Young and Paul and Tim Samaras, who were among the best and safest chasers in the field.

Being sandwiched between the I-40 and Canadian River left limited escape routes. This plus the ominous nature of the storm made me keep my distance, and I vacated the area as soon as I could.

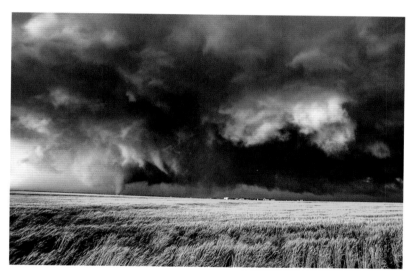

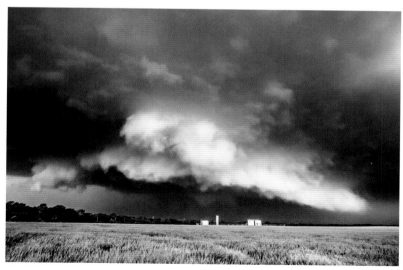

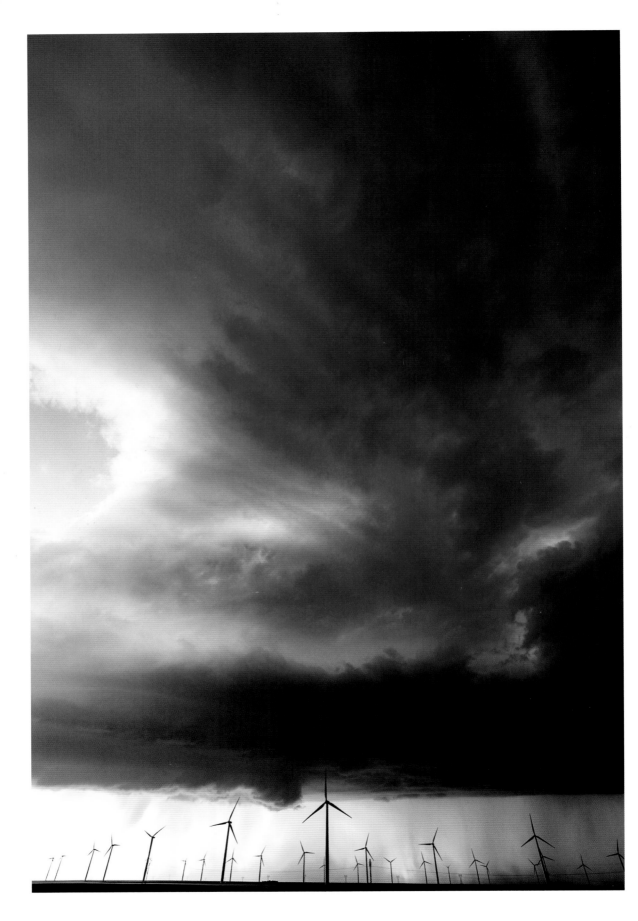

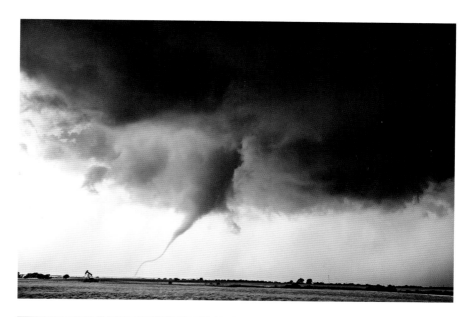

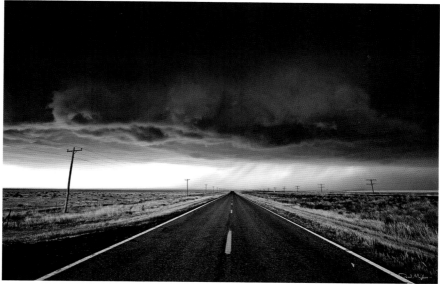

ROTATION (previous page)

A wall cloud appears under the striations of the rotating updraft of a supercell storm as it passes by a wind farm. Near Dodge City, Kansas. May 19th, 2011.

TIGHT ROPE (top)

A rope tornado drops from a storm near Fairview, Oklahoma, during a tornado outbreak day. It was the second tornado of that day. May 24th, 2011.

THE JOURNEY OF LIFE (bottom)

Boiling clouds from a rotating supercell storm that spawned a brief tornado limit my road options. Near Haswell Colorado, May 18th, 2011.

HOVERING SPACESHIP *(top)*

Image 1 of 2. Another high plains high-base supercell storm takes on the shape of an alien spacecraft. Sidney, Nebraska. May 19th, 2014.

GRAIN BIN ROTATION *(bottom)*

Image 2 of 2. As the storm heads over the town of Sidney, Nebraska, a lowering wall cloud starts to spin slowly, as seen here over the grain bin. Sidney, Nebraska.

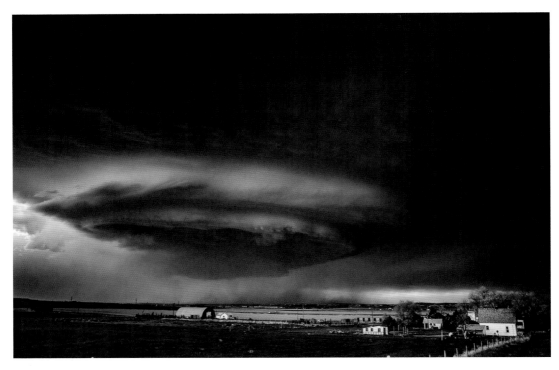

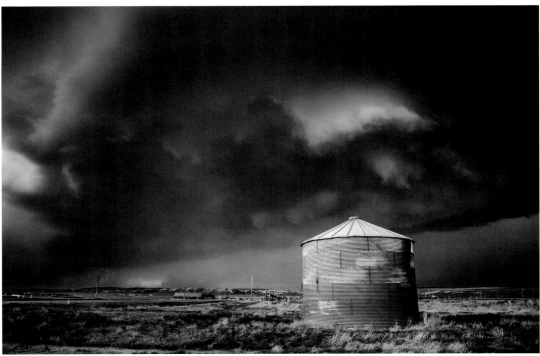

BACKROAD BEAST *(top)*

Image 1 of 2. A rotating wall cloud forms as the storm chases me down the dirt roads of Colorado. Video footage showed a rapid touchdown behind me for literally a few seconds. I had two great chases on two consecutive days down the exact same roads, taking the exact same course. East of Nunn, Colorado. June 23rd, 2014.

HUFF & I'LL PUFF *(bottom)*

Image 2 of 2. The same storm continues to rotate over three remote grain bins but starts collapsing soon after. East of Nunn, Colorado.

SPECIAL DELIVERY *(pages 44-45)*

A tornado struggles to touch down in Eastern Colorado, and a very slowly rotating funnel persists for a number of minutes. Despite the mailboxes, there were no homes in sight! Near Shamrock, Colorado. May 24th, 2016.

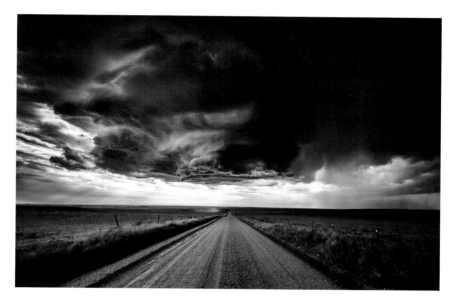

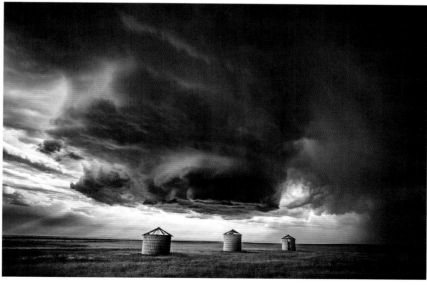

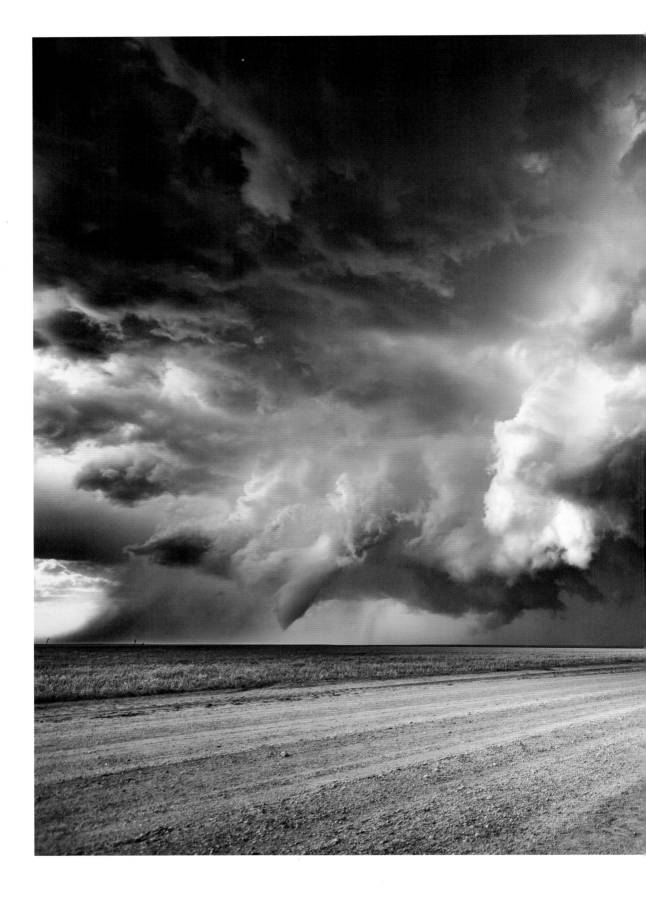

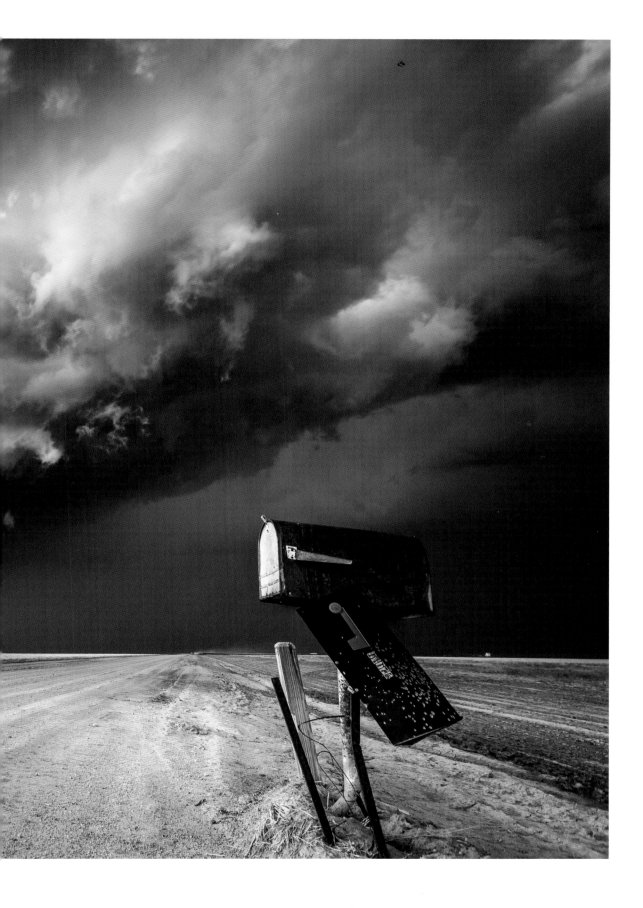

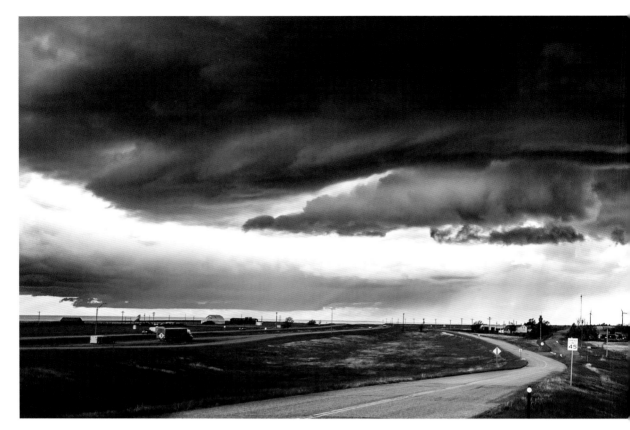

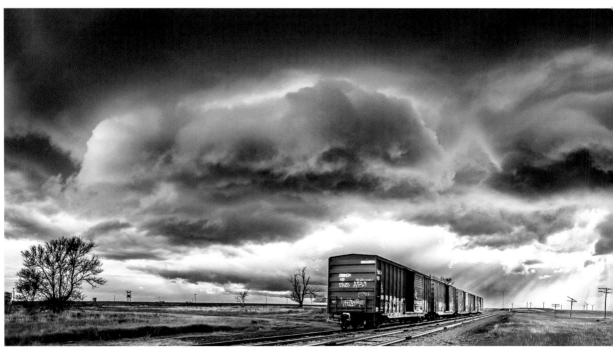

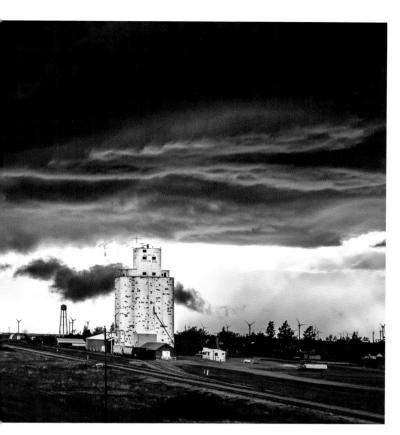

GENOA STORM #79 *(top)*

Storm clouds approach Genoa in Eastern Colorado by Interstate 70. May 22nd, 2015.

GENOA STORM #101

(bottom)

The storm rapidly develops and the clouds take on a crisp structure. May 22nd, 2015.

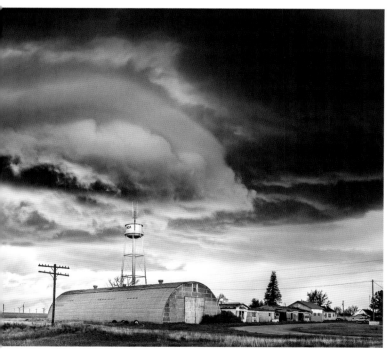

STORM MANIFEST *(top)*

Image 1 of 2. As the storm approaches vibrant box cars, the clouds start to look a little like a hand reaching out.

The word "manifest" is also a railway term for a freight train with a mixture of car types and cargoes. May 22nd, 2015. 7:10PM.

GENOA STORM #115 *(bottom)*

Image 2 of 2. As the storm moves out beyond the town of Genoa, Colorado, a rotating wall cloud forms, looking like a tornado might drop at any second. 7:25PM.

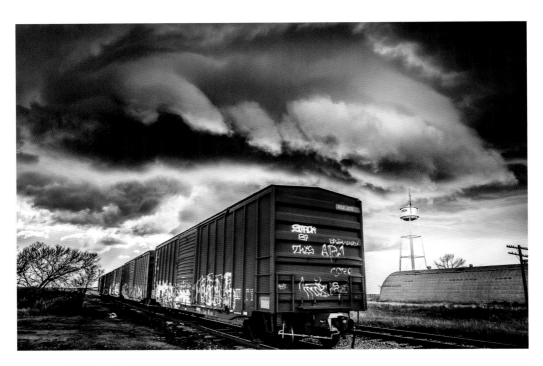

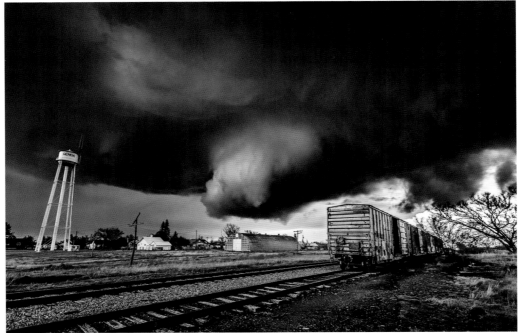

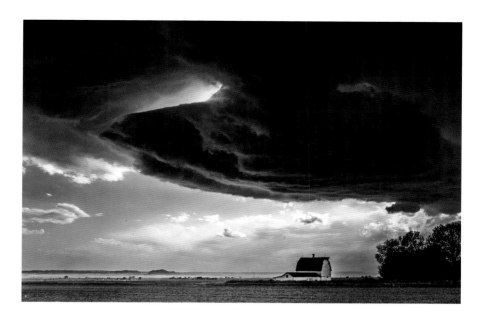

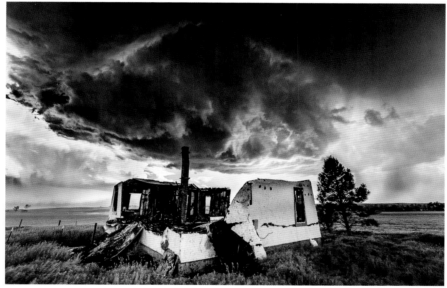

JINXED (top)

Image 1 of 4. A storm rapidly pops up near Minatare in Western Nebraska. I love chases like this, when I take a gamble on a lower-risk chase area. A higher risk was up near Rapid City, South Dakota, where there was a heavy rainstorm. This was a late initiation, but it was isolated and very photogenic. Only a handful of chasers were on this storm, and I believe I was the only one on it from initial formation to end. 7:30PM.

OPEN HOUSE (bottom)

Image 2 of 4. A burned-out house set the scene for this capture of a dramatic and rapidly growing wall cloud as I followed the storm due east along County Road 62A. June 2nd, 2015. 7:36PM.

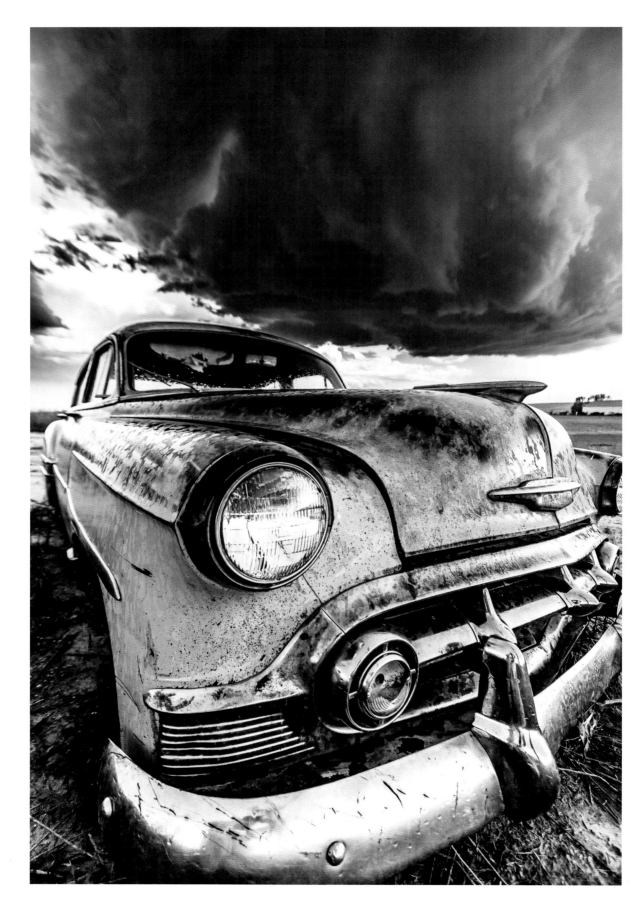

SHAKE, RATTLE 'N ROLL *(previous page)*
Image 3 of 4. A rusty old Chevy in a car boneyard endures the rapidly growing storm, which produced hail and a wall cloud. It's amazing how many great foregrounds I encountered in such a short distance! This car is no longer there. I deliberately took this route on the way from my home in Colorado to an art fair in Minneapolis.

NO MAN'S LAND *(below)*
Image 4 of 4. Just me, a field, and a rotating wall cloud. It is not often I get to claim a storm as all mine!

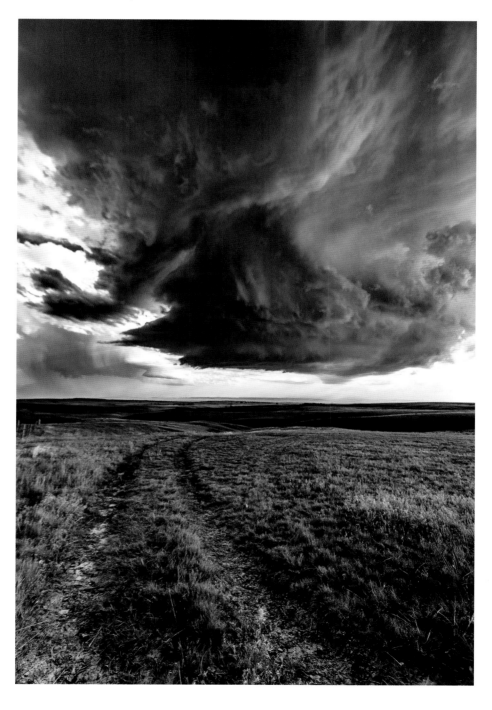

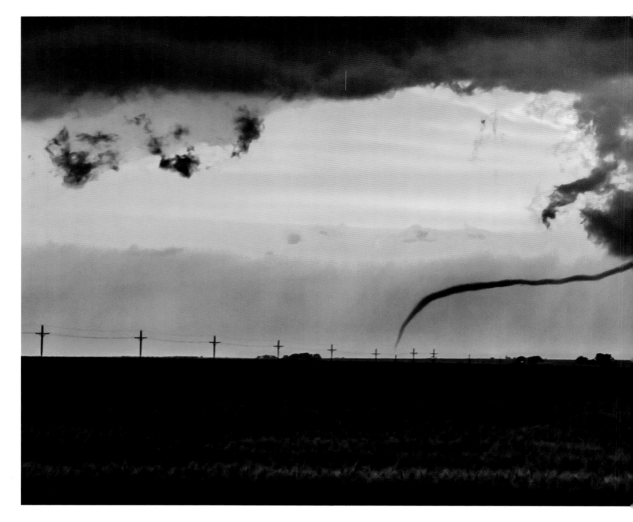

WHIPLASH *(above)*

A bizarre rope of a tornado worms its way to the ground at dusk near Russell, Kansas.

Low light made it difficult to get a good photograph. Ten minutes can make all the difference in getting into position for a great shot. May 25th, 2012.

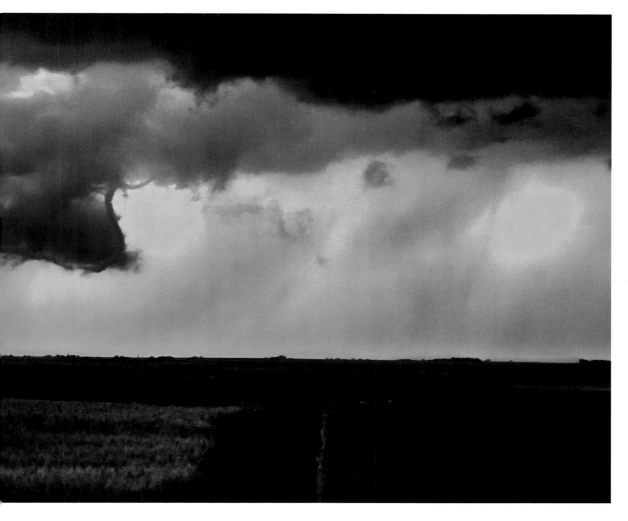

A bizarre rope of a tornado worms its way to the ground at dusk near Russell, Kansas.

CHAPMAN TORNADO #65 *(top)*

Image 1 of 6. My best chase of 2016. This tornado was on the ground for an astonishing 93 minutes and for the most part sustained a width of a 1/2 mile and reached EF4 strength, with zero injuries! How does that not make for a perfect chase?!

The shot was made 1 minute after initial touchdown, and you can see the great hook formation of the storm.

About 7 miles west of Solomon, Kansas. May 25th, 2016. 7:08PM.

DERAILED *(bottom)*

Image 2 of 6. After skirting around the Solomon River, I caught up to the storm again. It took an easterly course, almost paralleling Interstate 70 passing north of Abilene and Enterprise, so it missed the urban areas.

6 miles north-northwest of Solomon, Kansas. May 25th, 2016. 7:20PM.

½-mile wide, EF3, 93 minutes, 26-mile-long path with zero injuries!

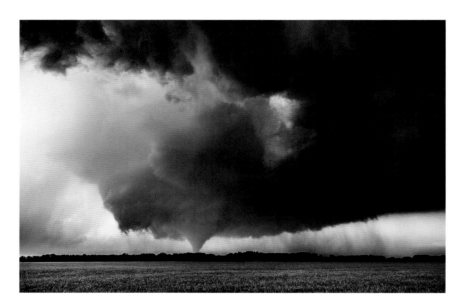

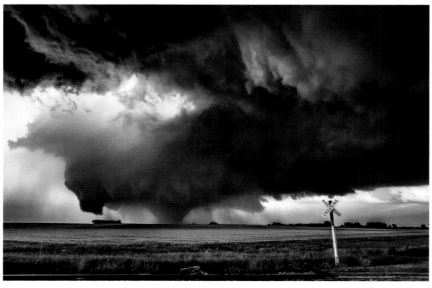

CHAPMAN TORNADO #121 *(top)*

Image 3 of 6. One of the problems of following behind a storm is the wet dirt roads (as seen here with the impassable county road) or even debris such as downed trees and power lines blocking roads.

2.5 miles due north of Solomon, Kansas. May 25th, 2016. 7:30PM.

RAIN WRAPPED *(bottom)*

Image 4 of 6. Being able to be this close to a large slow-moving tornado was amazing!

The tornado was approximately 1.5 miles north of me here, and watching the rain wrapping around the storm in bands was quite exhilarating. At about this time, the tornado crossed I-70, which was controlled by police—the benefit of a long straight track clearly visible tornado! It was, however, of great concern, as the tornado was closing in on Chapman, Kansas, but fortunately skirted just south of the town.

1.5 miles north-northeast of Detroit, Kansas. May 25th, 2016. 8:07PM.

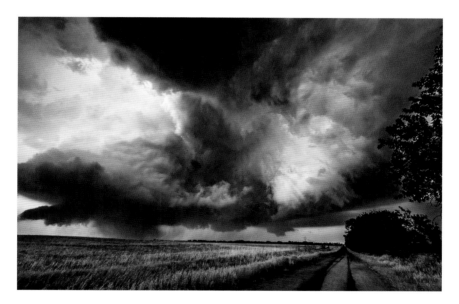

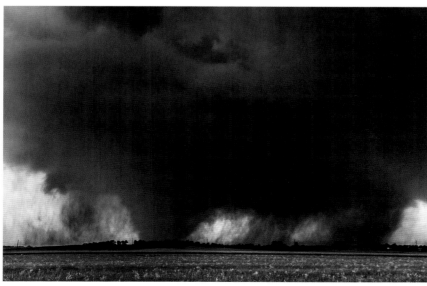

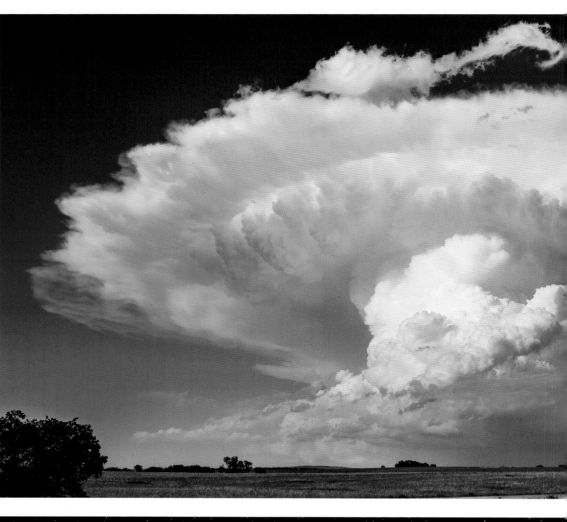
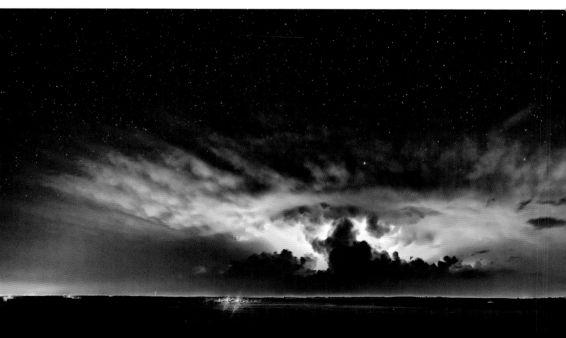

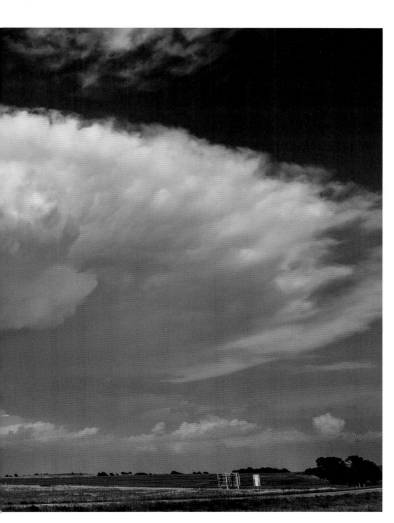

CHAPMAN ANVIL *(top)*

Image 5 of 6. The birth of the Chapman tornado storm with a strong updraft climbing cumulus tower and crisp anvil, looking west. May 25th, 2016. 6:09PM.

CHAPMAN AFTER DARK
(bottom)

Image 6 of 6. After dark and after the tornado had lifted, the storm maintained the same structure thoughout its life, though the cumulus tower had weakened. Note that the anvil is no longer as well-defined on the edges. May 25th, 2016. 10:07PM.

After dark and after the tornado had lifted, the storm maintained the same structure thoughout its life, though the cumulus tower had weakened.

CARHENGE LIGHTNING *(top)*

Two bolts of lightning emanated from the exact same spot and took the exact same course despite being 15 seconds apart. Captured in a 30-second exposure.

Carhenge is a replica of Stonehenge near Alliance, Nebraska. A bright orange moon rose on the horizon and can be seen under the storm clouds. June 13th, 2014.

SUNSET BOULEVARD *(bottom)*

The setting sun seen on the horizon creates an orange glow as lightning strikes from an approaching storm.

Taken near Sturgis, South Dakata. May 29th, 2014.

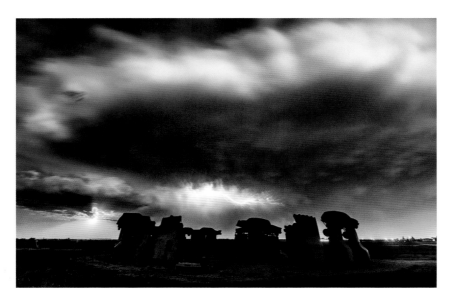

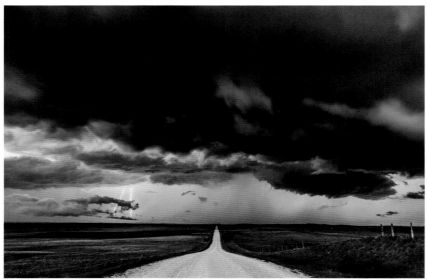

ELECTRIC BOOGALOO

(top)

A storm rolls off the Cheyenne ridge into the high plain of Northern Colorado at dusk. The structure of the clouds could not be seen by the naked eye but was made visible from a longer exposure—in this case, 12 seconds.

Photographed near Nunn, Colorado. June 1st, 2016.

ELECTRIC AVENUE

(bottom)

A dryline boundary between the moist and dry air masses fires up storms at dusk near Big Springs, Nebraska. The frequency of lightning was pretty much continuous. May 22nd, 2016.

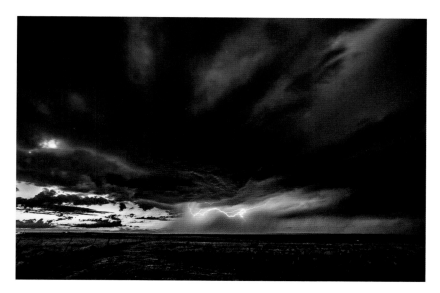

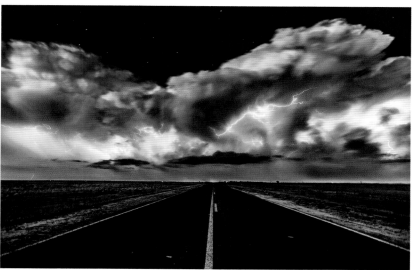

Two bolts of lightning emanated from the exact same spot and took the exact same course despite being 15 seconds apart.

MIDNIGHT ROAR

(pages 60-61)

A storm pops up rapidly, giving a great lightning display at night. City lights reflect the tungsten orange color on the underside of the anvil, while areas in shadow maintain a blue tint, set against a blanket of stars in the clear surrounding skies. More often than not, lightning takes on a purple tint in photos. Sterling, Colorado. June 28th, 2016.

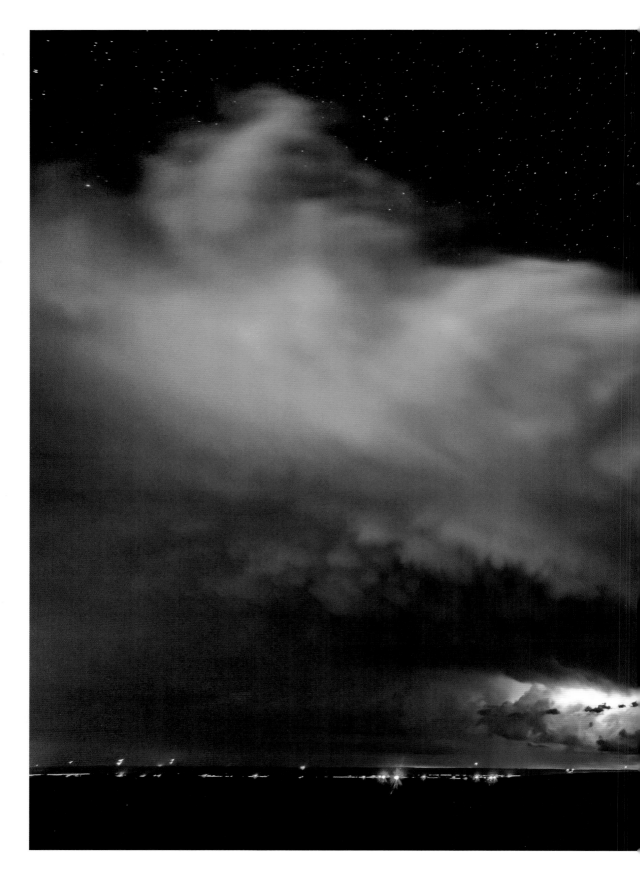

SKY NET *(top)*

A tornado-warned storm passes over down-town Chicago. Sirens whine as lightning webs its way across the skyline trying to find the path of least resistance to the ground. The entire streak of lightning took about 3 seconds to cross the sky. At one point, the lightning rods on the building buzzed, so I ducked inside and left the camera to run! August 5th, 2008.

HIGH-SPEED CONNECTION *(bottom)*

Bolts of lightning converged in the skies over Chicago before nosediving onto the antennae of the Sears Tower. This is one of my earliest captures of lightning from the roof deck of my old apartment—and it is one of the reasons I chose to live there! July 18th, 2006.

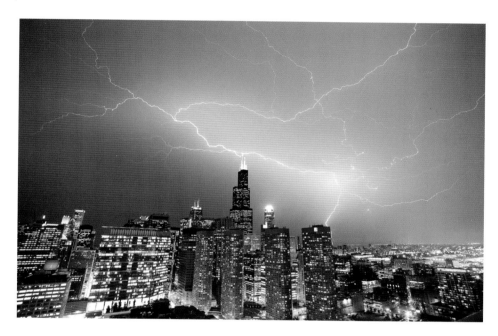

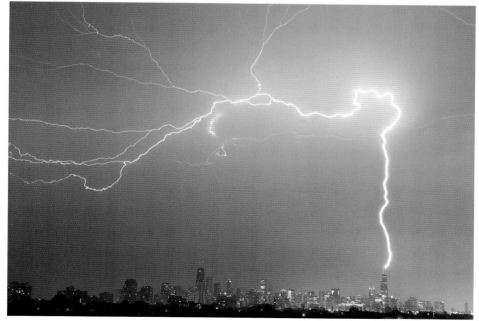

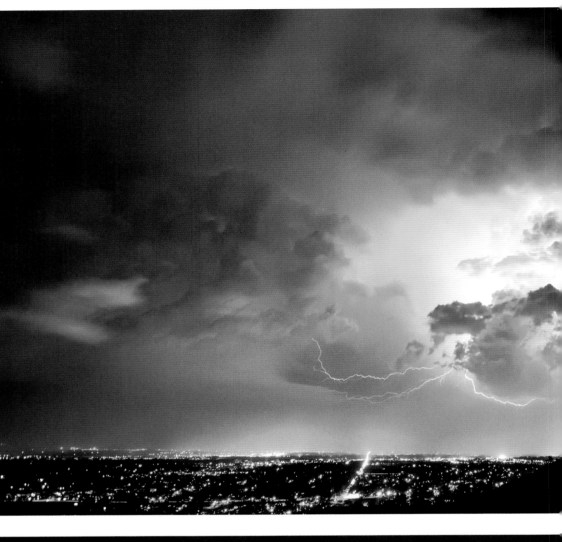
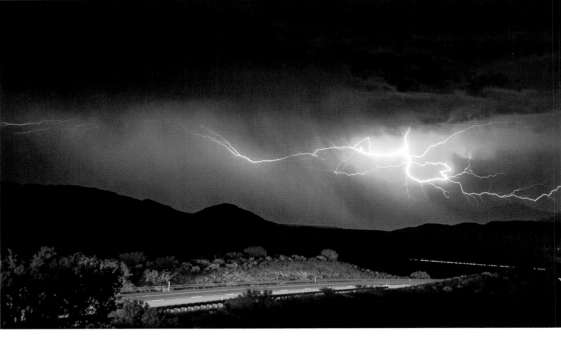

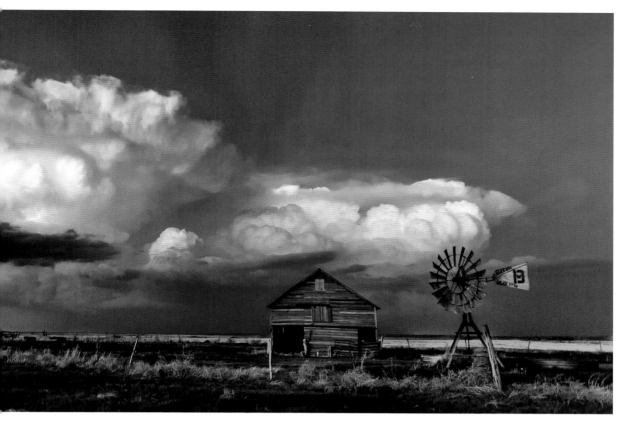

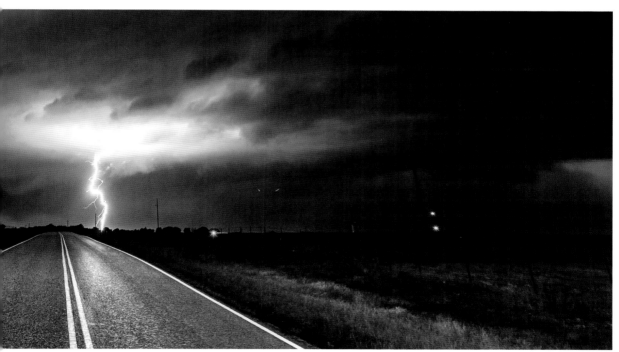

FIELDS OF GLORY *(top)*

Sunset rises up the towering clouds of a multicell storm. Stockton, Kansas, May 27th, 2012.

DOMINATION OF THE MOTHERSHIP *(bottom)*

A slow-moving supercell storm in Nebraska bulks up to later produce baseball-size hail and an amazing lightning show. Elba, Nebraska. May 4th, 2012.

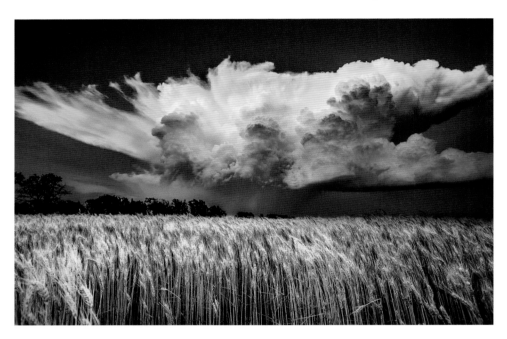

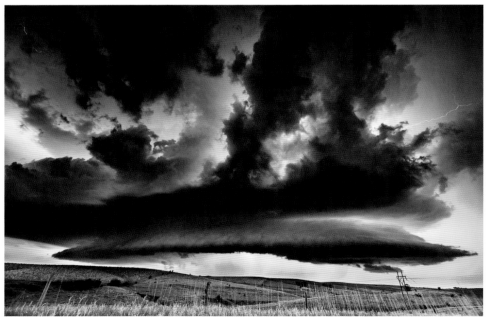

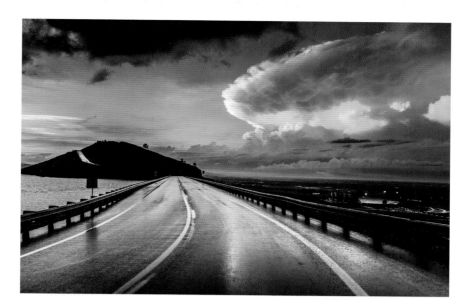

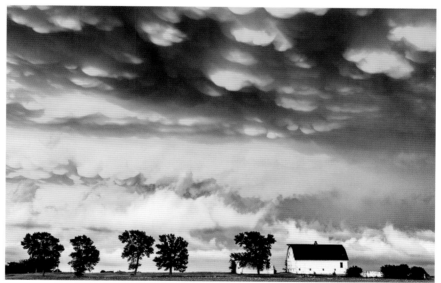

AFTER THE RAIN (top)

Wet roads after a heavy downpour by Horsetooth Reservoir in Fort Collins, Colorado, as the sunset lights up the storm's anvil. June 3rd, 2015.

GOLDEN AMBIENCE (bottom)

The last light of sunset colors the billowing mammatus clouds over a farm near Beaver Creek, Minnesota. I drove 1100 miles in a day with a chase partner hoping for a tornado, but the sunset was good enough for me! July 14th, 2009.

SINK OR SWIM (pages 78–79)

A severe storm passes through parched farmlands in Eastern Colorado, taking on the appearance of an ocean in the sky prior to producing a tornado. Near Shamrock, Colorado. May 24th, 2016.

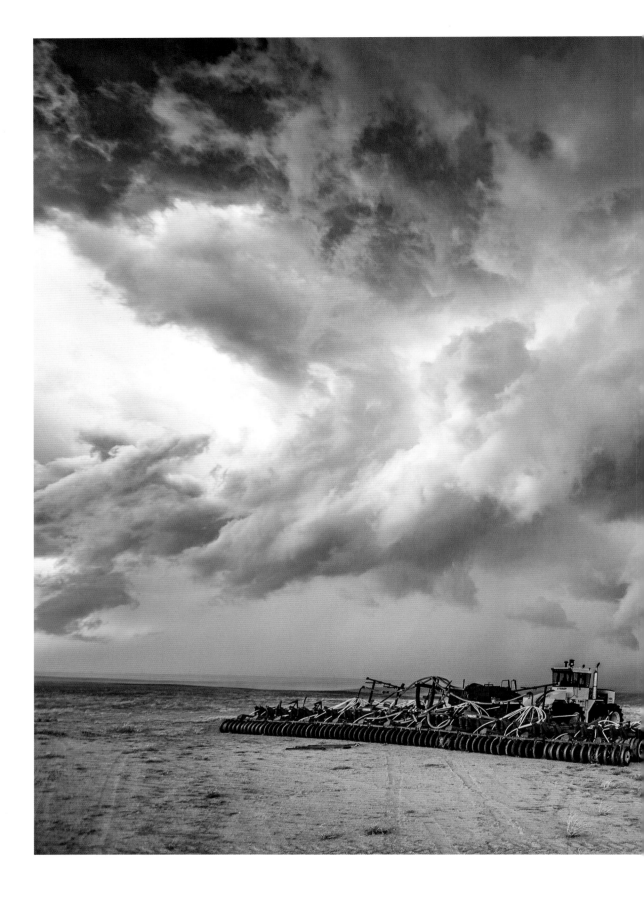

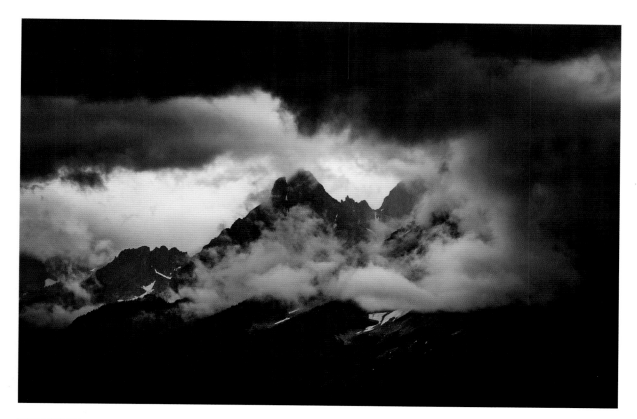

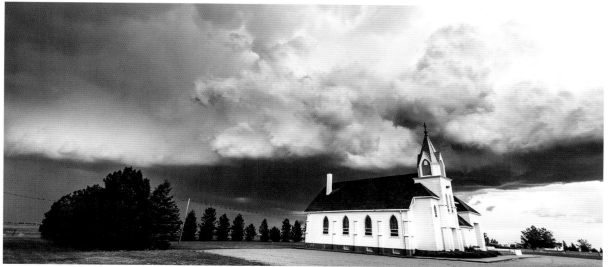

TETON CLOUDS *(top)*
Rain showers pass through the Teton
Mountains, Wyoming. August 5th, 2014.

HEAVEN'S DOOR *(bottom)*
A hail-producing supercell storm with some
decent hail passes behind a remote church.
Sidney, Nebraska. May 28th, 2013.

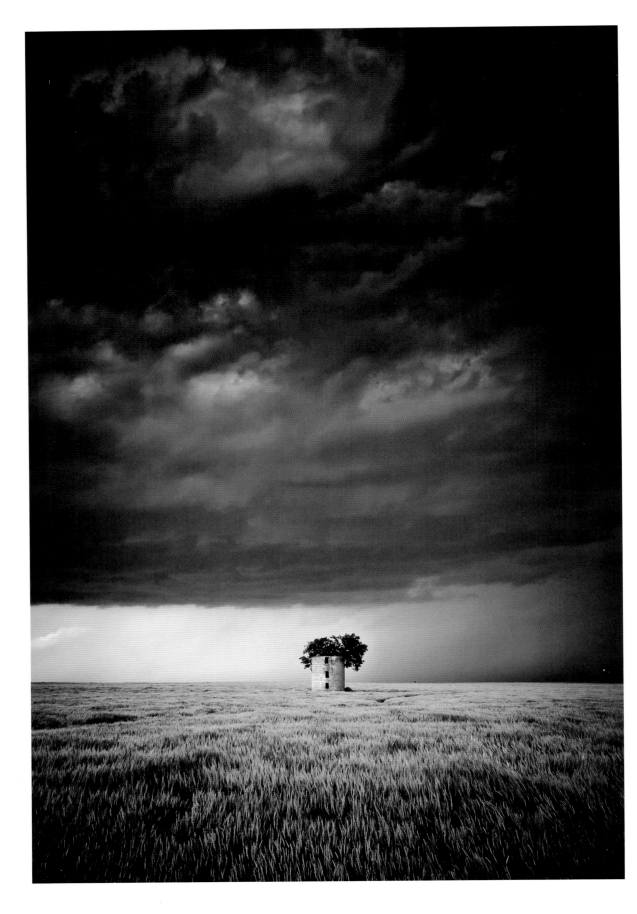

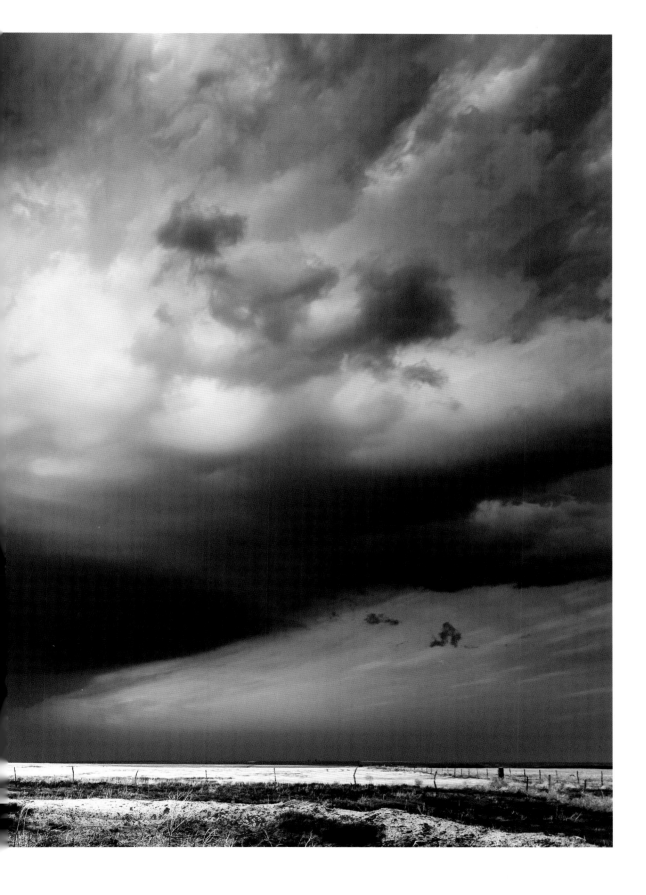

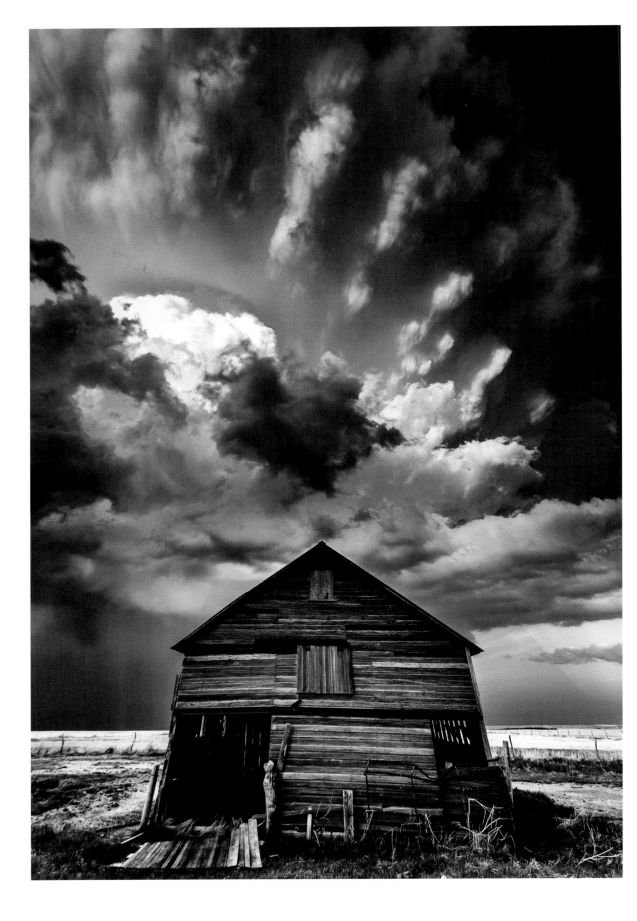

REFUGE *(previous page)*

Boiling clouds pass over an abandoned barn in the Midwest by a cornfield. My first-ever solo storm chase! Near Bloomington, Illinois. July 13th, 2004.

DREAM CATCHER *(top)*

Clusters of fast-moving storms form in Wyoming, but some hidden gems could be found in the clearings. North of Cheyenne, Wyoming. June 17th, 2015.

RAINBOW ROAD *(bottom)*

A double rainbow reflects off rain and hail down the backroads of Colorado. South of Stoneham, Colorado. June 23rd, 2016.

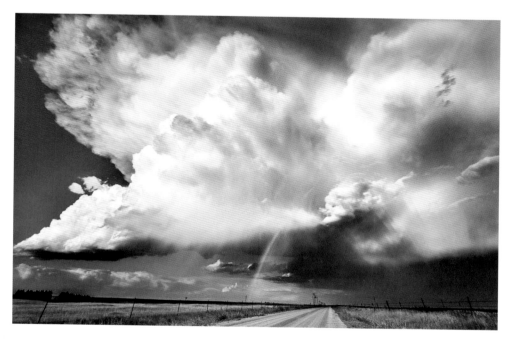

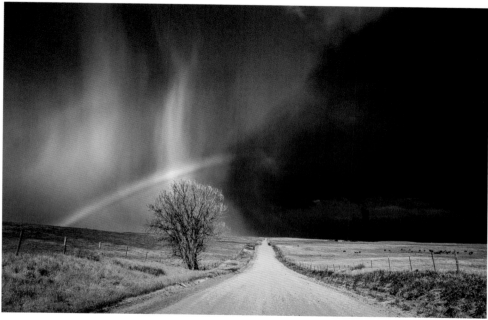

ST. MICHAEL'S MOUNT *(top)*

As the tide rises, the walkway to St. Michael's Mount, in England, is submerged. A 1-minute exposure smooths the water's surface and captures the motion of the clouds.

FROZEN MOTION *(bottom)*

A long exposure blurs the cloud and wave motion as icebergs sit on the black volcanic beach at Jökulsárlón, Iceland.

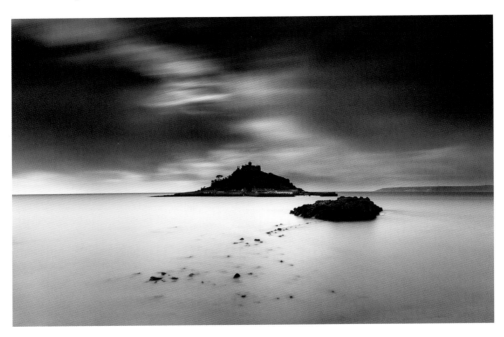

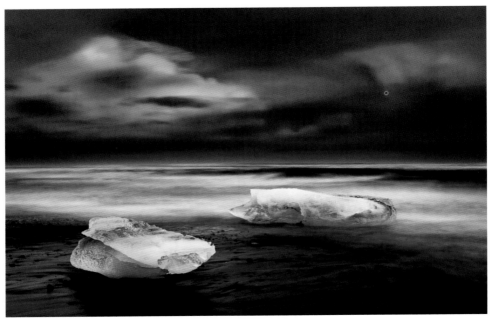

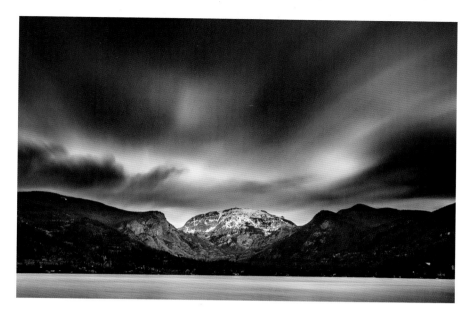

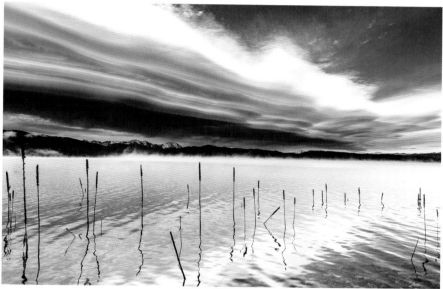

MOUNT BALDY (top)

The first snow showers of the season pass over Mount Baldy by Grand Lake, the largest natural lake in Colorado. A 2-minute exposure.

LAKE GRANBY LENTICULARS #1 (bottom)

Lenticular clouds at sunrise over Shadow Lake near the town of Grand Lake (just outside Rocky Mountain National Park), Colorado.

THREE SISTERS SUNSET #1

(pages 106–107)

Lenticular clouds form over the Three Sisters Mountains at sunset, near Bend, Oregon. Orographic lift and often high winds aloft help form lenticular clouds.

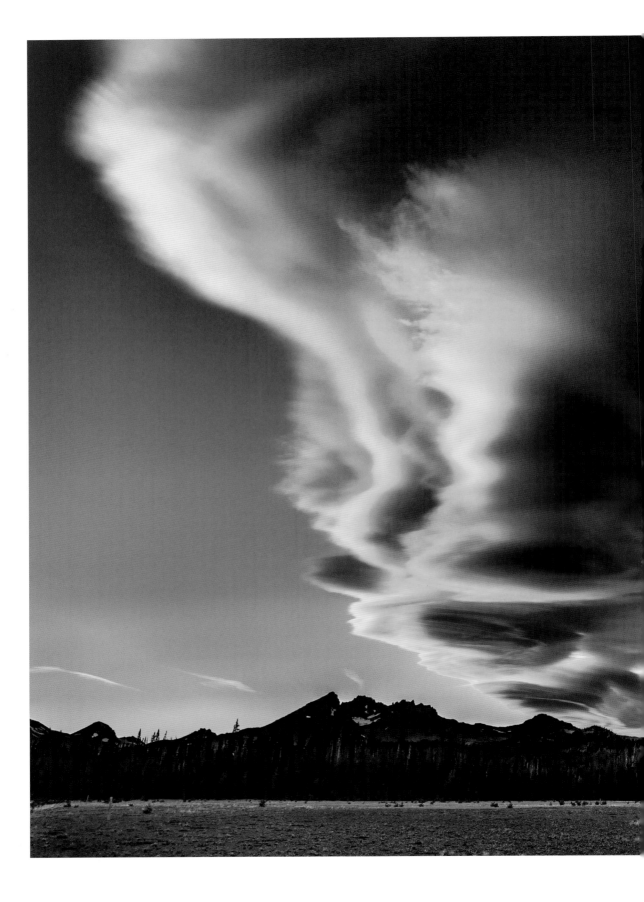

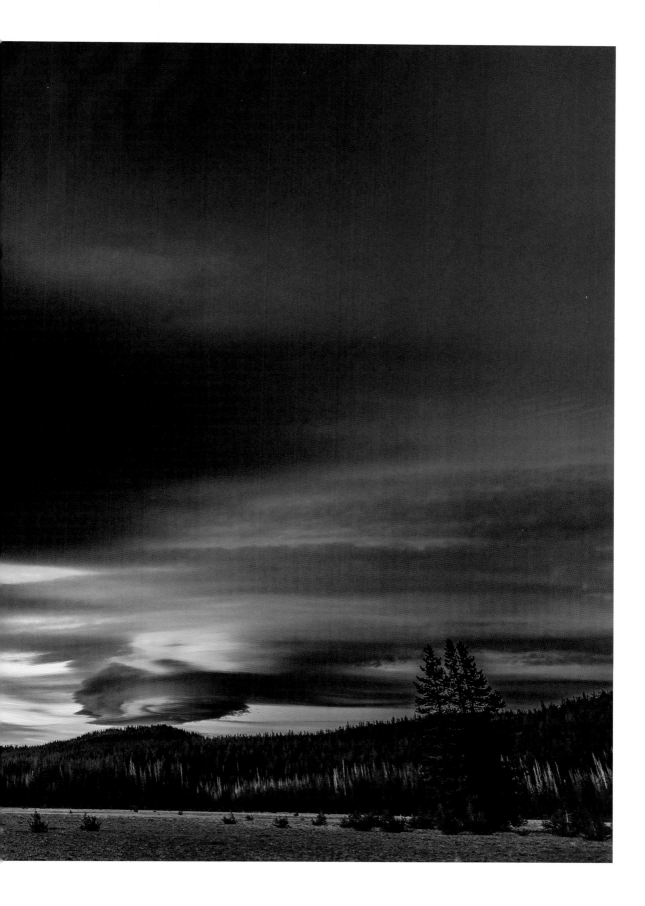

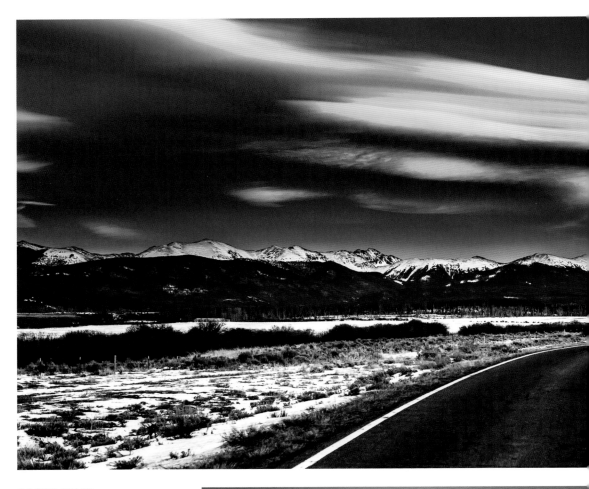

ROCKY ROAD *(top)*
High winds at altitude force air over Rocky Mountain National Park (orographic lift) creating the stacked-plate appearance. Rand, Colorado.

LAKE GRANBY LENTICULARS #3 *(bottom)*
Sunset over Lake Granby, Colorado, with lenticular clouds.

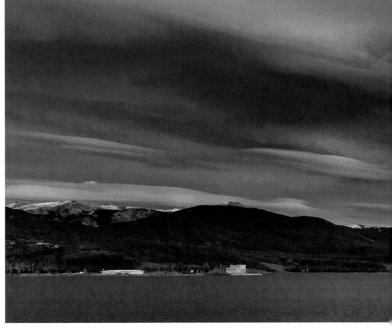

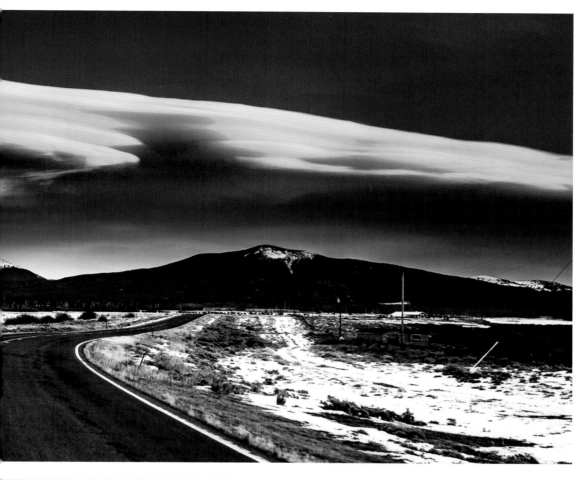

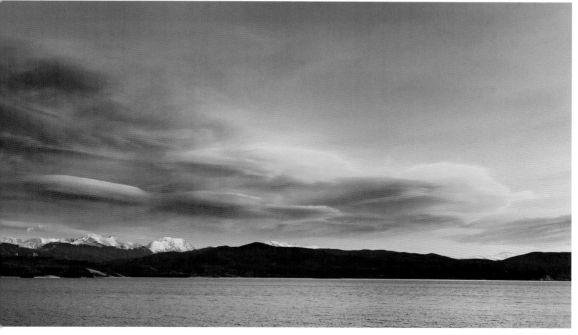

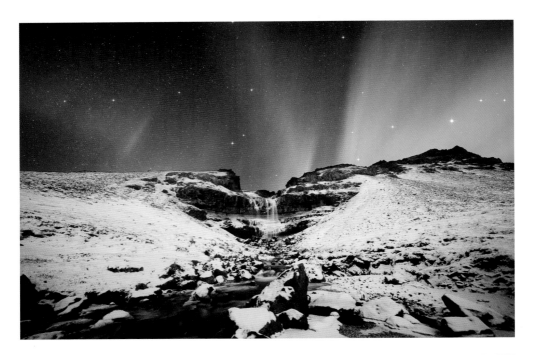

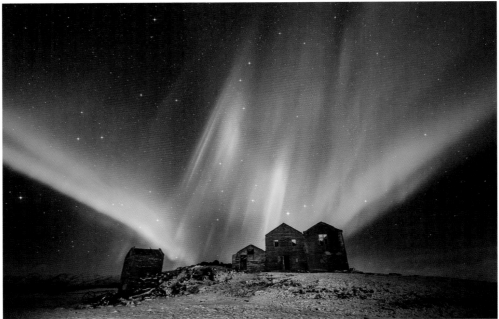

BERGÁRFOSS LIGHTS (top)

Northern lights dance in the skies over mountains in Iceland as a waterfall cascades down the rocks.

GHOSTS OF THE PAST (bottom)

The aurora borealis illuminates the remains of an old farm in Iceland. Native Americans believe the lights to be the spirits of ancestors dancing in the sky.

GUIDING LIGHTS *(top)*

The first burst of northern lights during a great night in Iceland. The headlights of a car can be seen traveling toward the bridge as glacial ice washes down the river.

ICELANDIC LIGHTS #1 *(bottom)*

Rich purples add to the green bands of the northern lights in Iceland. Shot by an abandoned farm.

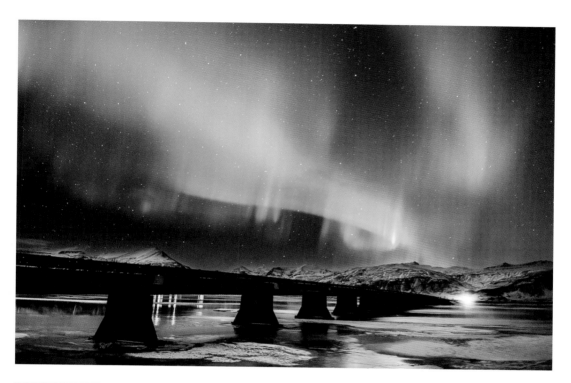

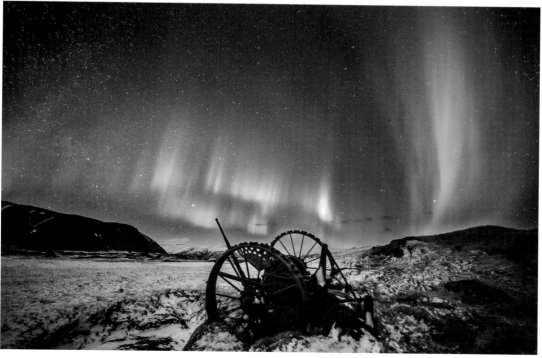

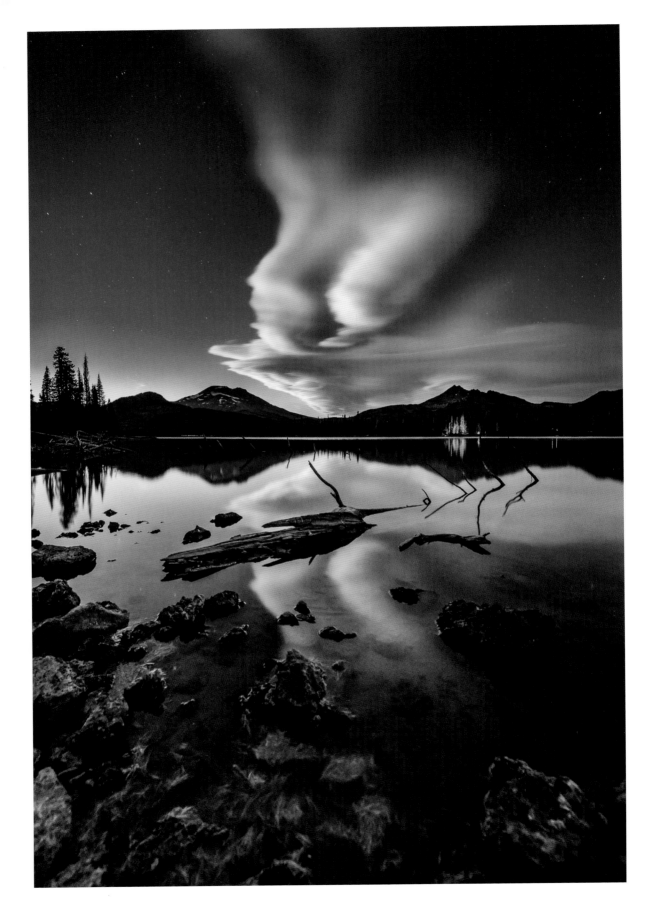

SPARKS LAKE #2 *(previous page)*

Lenticular clouds reflect in Sparks Lake at dusk, while a campfire illuminates trees in the background. Near Bend, Oregon.

THREE SISTERS SUNSET #2 AND #29

(top and bottom)

Lenticular clouds form over the Three Sisters Mountains at sunset near Bend, Oregon.

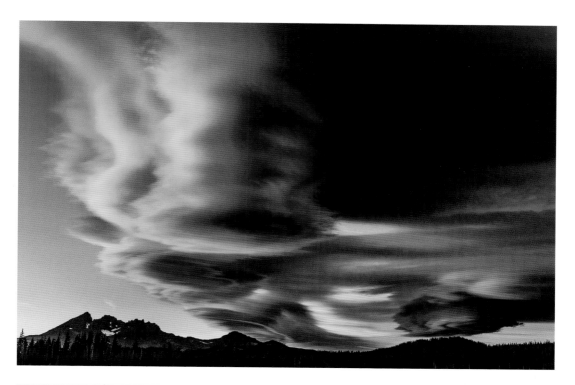

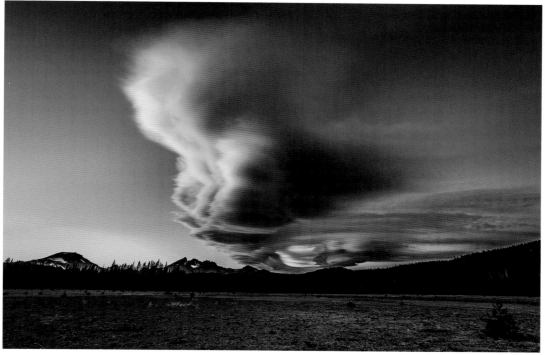

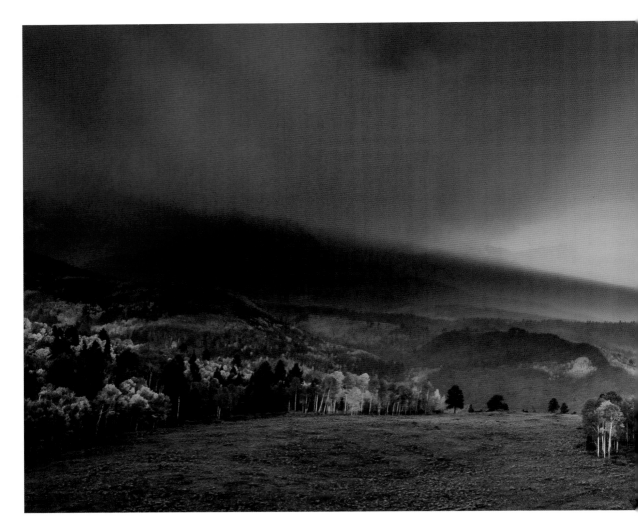

MOUNTAIN RAYS *(above)*

Sun filters under the clouds and makes the rain glow orange in the San Juan Mountains, Colorado, in Fall. If you follow the line of orange light to the right, you can just make out the sun peeking over the mountains.

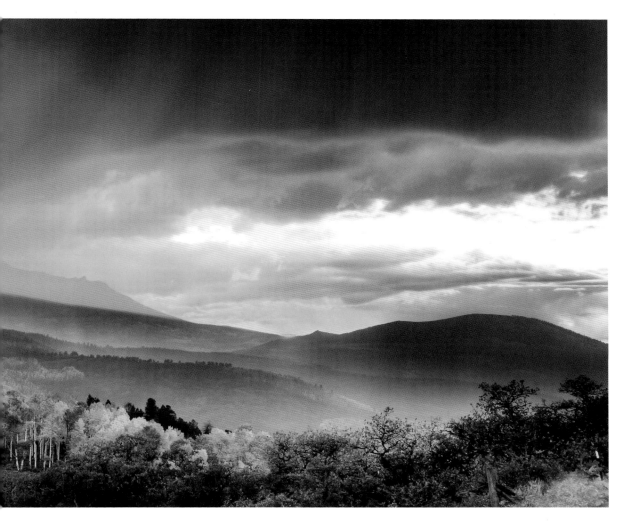

Sun filters under the clouds and makes the rain glow orange in the San Juan Mountains.

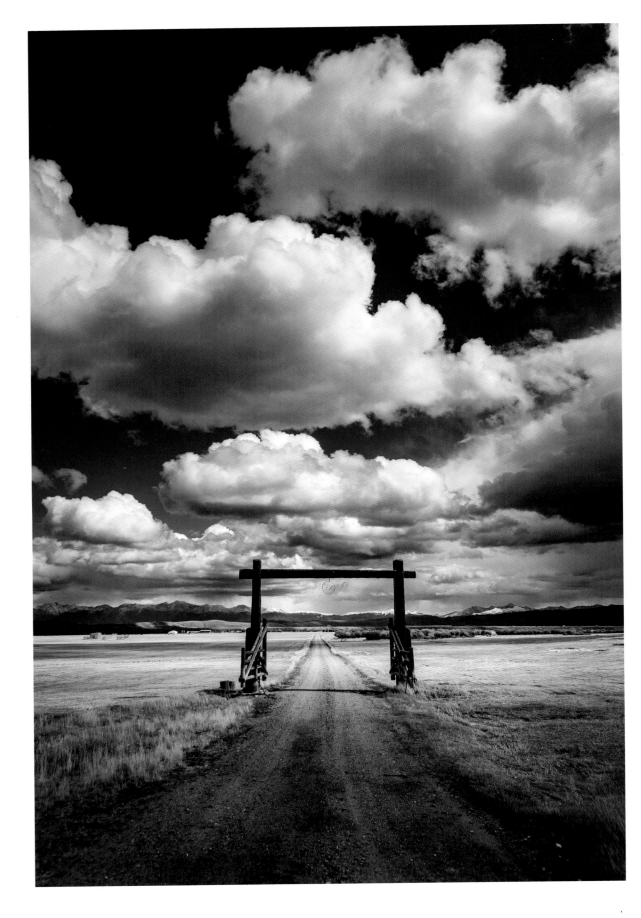

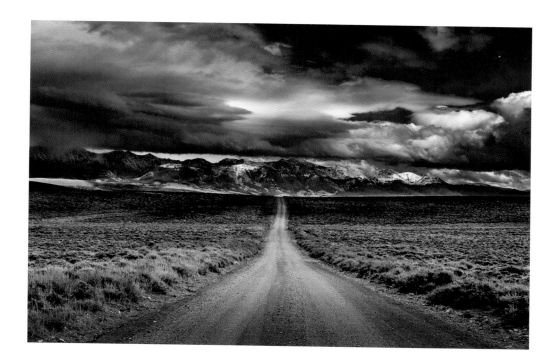

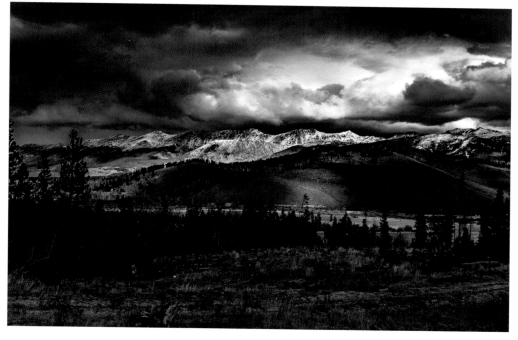

GATEWAY *(previous page)*
Fair-weather cumulus clouds precede snow showers at 8400 feet above sea level near Rand, Colorado.

WALDEN SNOW STORM #1 AND #2
(top and bottom)
Snow showers approach the mountains near Walden, Colorado, as I explore some back-road areas.

HORSETOOTH FOG *(top)*
Morning fog blankets
Fort Collins, Colorado, as
viewed from Horsetooth
Reservoir, casting long
shadows.

WALDEN SNOW STORM #3
(bottom)
Snow showers engulf Bear
Mountain and Flat Top
Mountain in the Zirkel
Wilderness.

Taken from the Arapaho
National Wildlife Refuge
south of Walden, Colorado.

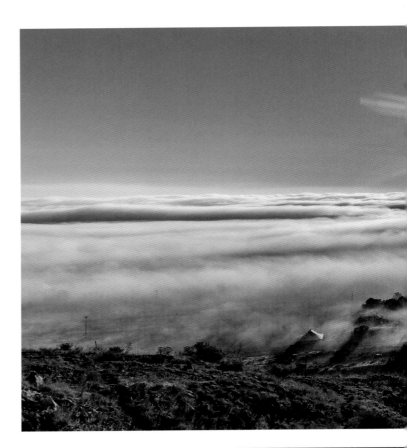

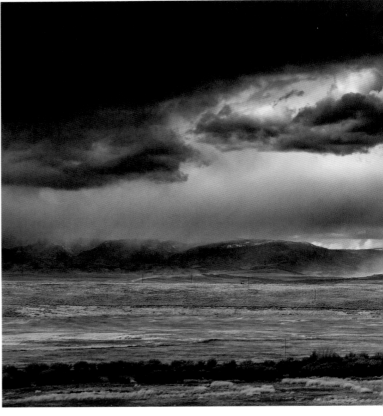

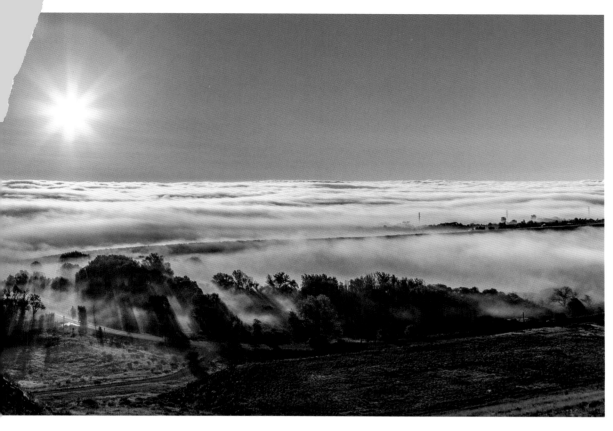

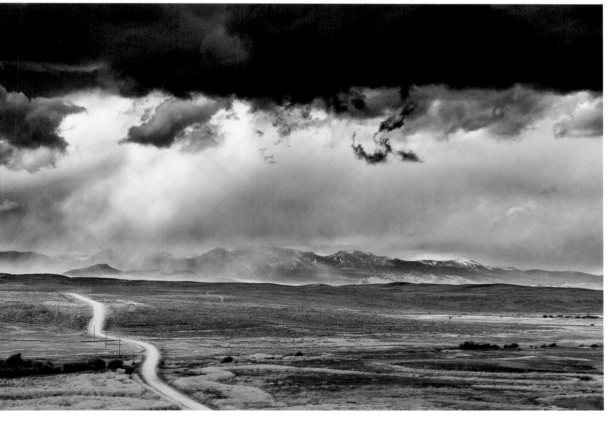

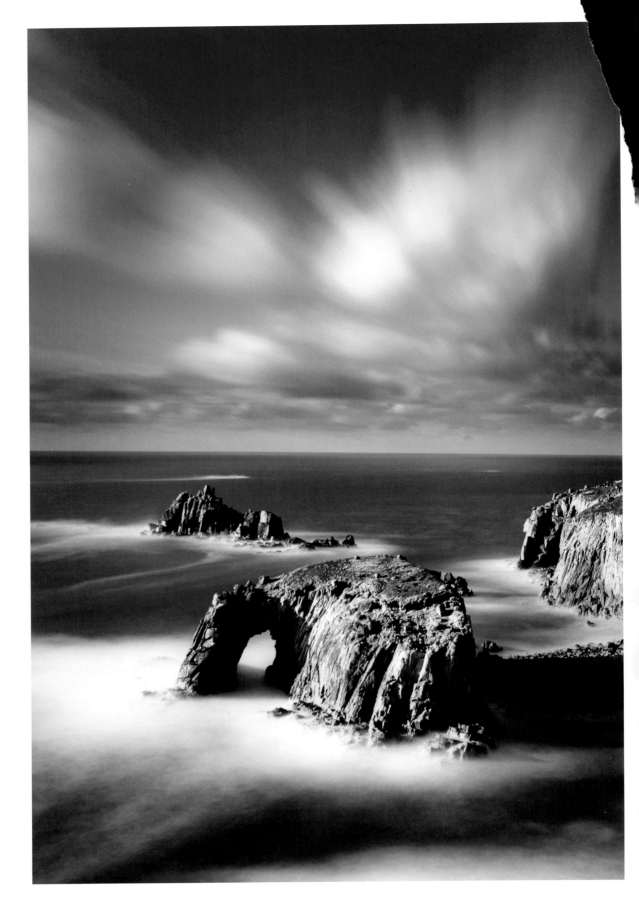

ATLANTIC SWELL *(previous page)*
A long exposure captures the motion of clouds and ocean on a windy day off the coast of England at Land's End.

SHIP TO SHORE *(top)*
The remains of a 100-year-old shipwreck rest on the shores of Iceland. A 30-second exposure captures the motion of the clouds and creates the feeling of fleeting time as the mountains endure the test of time.

CANNON BEACH *(bottom)*
Sunset over Cannon Beach, Oregon.

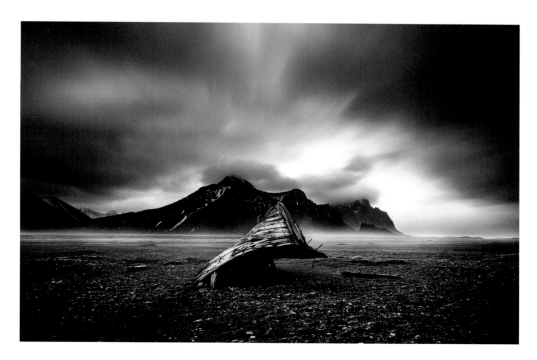

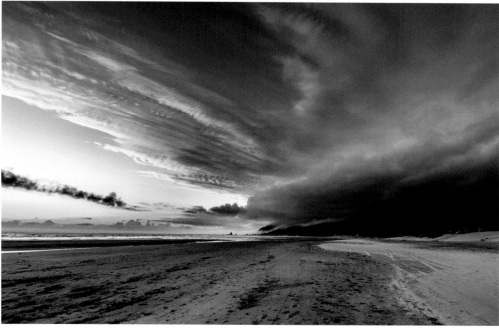

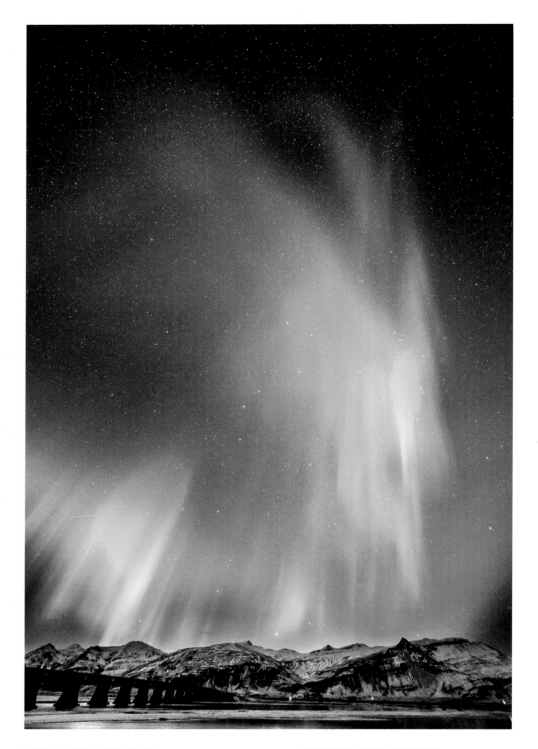

ICELANDIC LIGHTS #3 *(above)*
Vibrant northern lights on the south coast of Iceland.

RIPPLED REFLECTIONS *(following page)*
Northern lights reflect off glacial melt in southern Iceland.

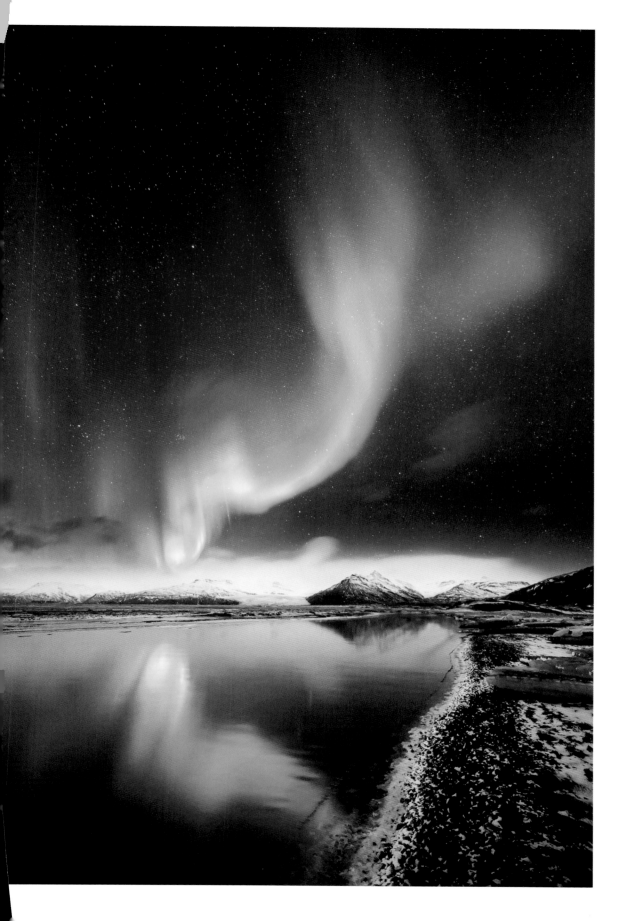

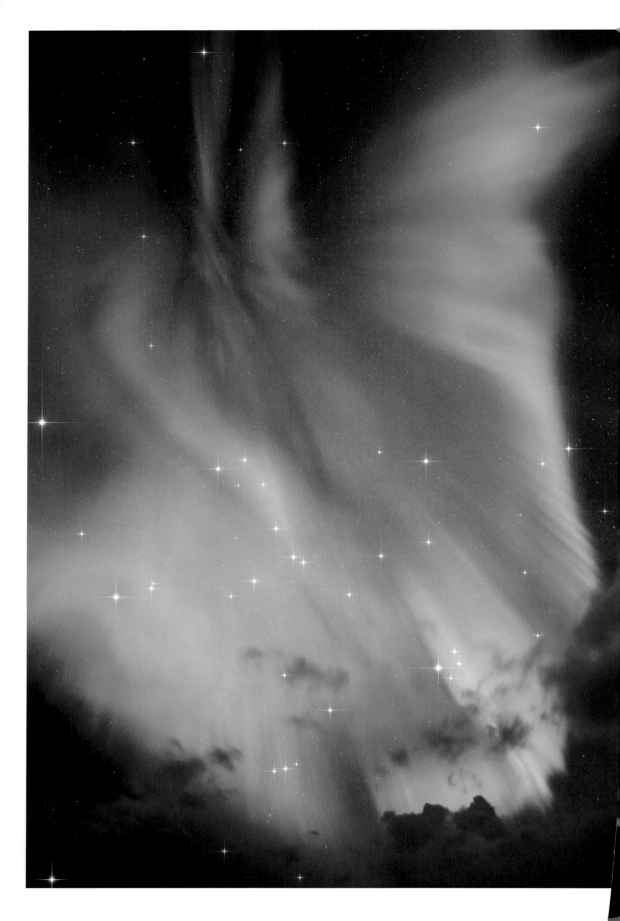

CORONA *(previous page)*

The corona of the aurora borealis (or northern lights) is the central position, from which the lights radiate outward, seen overhead and high in the sky.

RIVER LIGHTS #2 *(top)*

Northern lights reflect off glacial melt in southern Iceland.

ICELANDIC LIGHTS #2 *(bottom)*

Aurora borealis sparks reflections in the glacial river runoff.

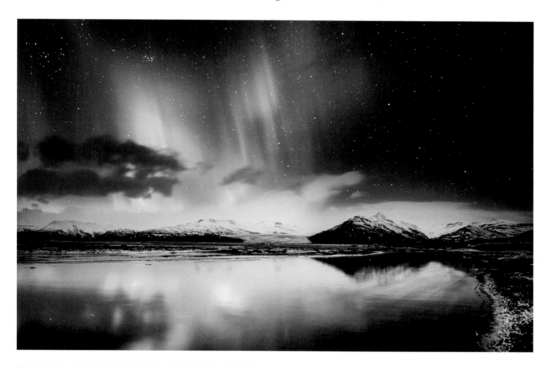

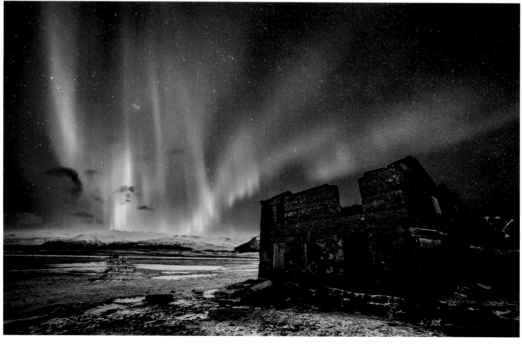

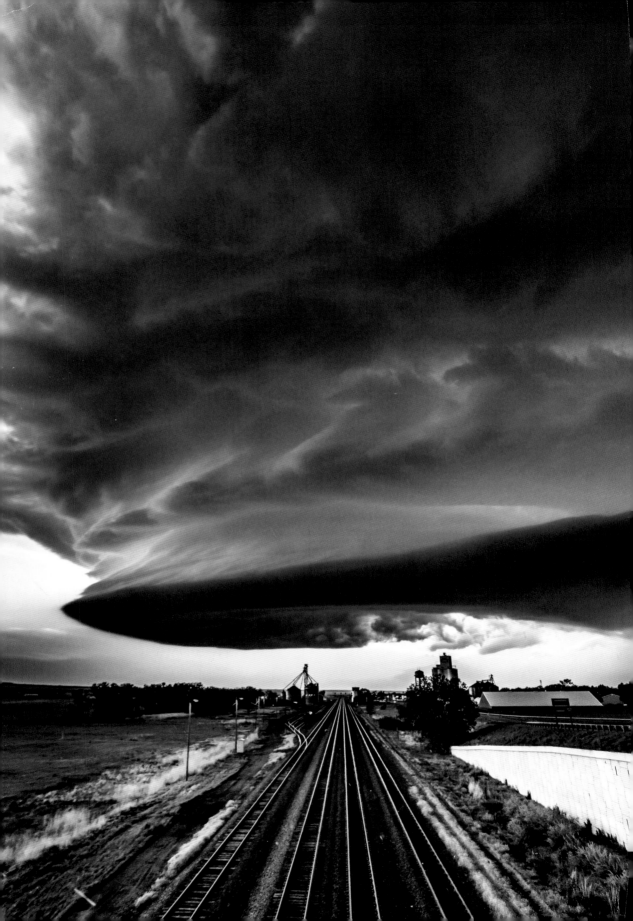

INDEX

The Complete Guide to Bird Photography

Jeffrey Rich shows you how to choose gear, get close, and capture the perfect moment. A must for bird lovers! *$29.95 list, 7x10, 128p, 294 color images, index, order no. 2090.*

Master Low Light Photography

Heather Hummel takes a dusk-to-dawn tour of photo techniques and shows how to make natural scenes come to life. *$37.95 list, 7x10, 128p, 180 color images, index, order no. 2095.*

Shoot Cold

Whether you live in the city or country, Joe Classen shows you how to shake the cabin fever and make winter your most creative and exciting photography season. *$37.95 list, 7x10, 128p, 250 color images, index, order no. 2101.*

Photographing Water

Heather Hummel walks you through techniques for capturing the beauty of lakes, rives, oceans, rainstorms, and much more. *$37.95 list, 7x10, 128p, 280 color images, index, order no. 2098.*

Macrophotography

Biologist and accomplished photographers Dennis Quinn shows you how to create astonishing images of nature's smallest subjects. *$37.95 list, 7x10, 128p, 180 color images, index, order no. 2103.*

Bushwhacking: Your Way to Great Landscape Photography

Spencer Morrissey presents his favorite images and the back-country techniques used to get them. *$37.95 list, 7x10, 128p, 180 color images, index, order no. 2111.*

How to Photograph Bears

Joseph Classen reveals the secrets to safely and ethically photographing these amazing creatures in the wild—documenting the beauty of the beast. *$37.95 list, 7x10, 128p, 110 color images, index, order no. 2112.*

Exploring Ultraviolet Photography

David Prutchi reveals how ultraviolet photography can be used for artistic and scientific purposes. *$37.95 list, 7x10, 128p, 130 color images, index, order no. 2114.*

Underwater Photography

Take an underwater journey with Larry Gates as he explores a hidden world and reveals the secrets behind some of his favorite photographs created there. *$37.95 list, 7x10, 128p, 220 color images, index, order no. 2116.*

Crush the Box

Richard Sturdevant's conceptual images may start as traditional photographs—but extreme postproduction takes them way beyond the expected! *$37.95 list, 7x10, 128p, 180 color images, index, order no. 2122.*